Muncy

D1451209

On the front cover: This photograph shows Main Street in Muncy around 1910. (Courtesy of the Muncy Historical Society.)

On the back cover: The Muncy Historical Society and Museum of History, located at 40 North Main Street and founded in 1936, focuses on preservation and conservation of the rich history and heritage of Muncy and surrounding communities. Its extensive museum is filled with relics of local interest, and its reference room contains area histories and genealogies as well as many original documents and early records. (Courtesy of the Muncy Historical Society.)

POSTCARD HISTORY SERIES

Muncy

To Mollie
Best wishes!
Robin Van Auken

Robin Van Auken for the Muncy Historical Society

ARCADIA
PUBLISHING

Published by Arcadia Publishing
Charleston SC, Chicago IL, Portsmouth NH, San Francisco CA

Printed in the United States of America

Library of Congress Catalog Card Number: 2006930465

For all general information contact Arcadia Publishing at:
Telephone 843-853-2070
Fax 843-853-0044
E-mail sales@arcadiapublishing.com
For customer service and orders:
Toll-Free 1-888-313-2665

Visit us on the Internet at www.arcadiapublishing.com

Dedicated to the members and volunteers of the Muncy Historical Society.

CONTENTS

ACKNOWLEDGMENTS

The Muncy Historical Society is a vibrant, all-volunteer organization committed to the preservation and conservation of Muncy's rich heritage. Its board of directors, trustees, and volunteers have revitalized the society and injected a sense of volunteerism within the community. Newly energized, this small group has tackled significant projects, earning it national recognition and respect.

In the past decade, Muncy Historical Society has reclaimed the Old Walton Graveyard and the Old Hill Burying Ground, rehabilitating the burial sites of the town's founders and early pioneers. Its members also restored the Eight Square School, built on the site of the oldest public school in Lycoming County. In doing so, they received the prestigious Pennsylvania Preservation 2001 Initiative Award.

The society also received honors for its Civil War Soldiers' Monument project, which included the publication of biographies of local Civil War casualties in *Priceless Treasures*, and the redesign of the monument site to accommodate the names of 64 casualties overlooked when the memorial was dedicated in 1869.

The society has reconnected Muncy with the West Branch of the Susquehanna River, and the historic West Branch Canal. Its members salvaged the cabin of an authentic Pennsylvania Canal Packet Boat, reconstructing the 1860s boat and creating a traveling educational exhibit. With the donation of an 11-acre parcel of land, the society is developing the Muncy Canal Heritage Park and Nature Trail, where it also hosts a public archaeology dig.

I would like to thank Linda Poulton, editor of *Now and Then*, the society's nationally recognized magazine of history, biography, and genealogy. Her keen sense of history and her skill as a writer and editor has guided all aspects of this book.

Unfortunately, it is not possible to acknowledge all of the postcard artists and photographers whose work is represented herein. However, their work is being revived by Muncy artist Judy Tamagno. Her pen-and-ink renditions of "Historic Muncy" have helped to promote the charming Colonial architecture of the town, as well as her limited-edition prints of local farms and barns.

INTRODUCTION

The postcards collected in this book represent a brief period in the history of Muncy, a borough in north-central Pennsylvania. One of the earliest settlements in the West Branch Valley, Muncy and its residents were participants in some of the most significant historic events in the making of the American frontier, including the French and Indian War and the Revolutionary War.

Explorers recognized its importance because of its proximity to the Susquehanna River and the numerous Native American trails that crisscrossed the landscape. Pioneers cleared land, planted crops, and built cabins as early as 1752, hoping to farm and trade with the Munsee Indians who lived nearby.

In 1797, brothers Benjamin and William McCarty and Isaac Walton laid out the town of Pennsborough. Derisively nicknamed "Hardscrabble," the small village grew slowly. Pennsborough was incorporated as a borough on March 15, 1826, and then, on January 19, 1827, the name of Pennsborough was changed to Muncy.

John P. Schuyler and Joshua Alder purchased 50 acres that became known as Port Penn. The neighborhood would first be dissected by the West Branch Canal and later the Philadelphia and Reading Railroad. Both the canal and railroad would be important to Muncy's growth. Manufacturing flourished, and the small community supported a variety of trades, products, and businesses.

Photographic postcards from the "Golden Age of Postcards" (1898 to 1918), however, cannot depict this early history, and even Muncy's pre-Civil War era is represented by nostalgic landmarks such as abandoned canals and buildings.

Muncy is segregated into four chapters. The first chapter, Society, is filled with postcards of the Muncy Historical Society, the conserver of Muncy relics, area churches, and schools. Muncy was home to two extraordinary institutions: the Muncy Seminary for young ladies, which opened in 1841, and the Muncy Normal School, a pioneer teachers' institute.

The second chapter, Neighborhoods, features postcards of Muncy's residential areas and its bustling downtown. Quaintly dubbed the "Williamsburg of Pennsylvania," Muncy is home to many beautiful and historic homes of Victorian-, Georgian-, and Federal-style architecture. Its annual Historic Homes Tour, sponsored by Muncy Historical Society, lures visitors from neighboring states eager to step into buildings and houses designed by world-famous architects. Muncy's St. James Episcopal Church is an example of the Gothic Revival that was introduced by architect Richard Upjohn, who also rebuilt Trinity Church in New York City.

The third chapter, Business and Industry, is replete with postcards and photographs of Muncy's earliest mercantiles and factories, some of which still exist and keep the town employed.

Historically Muncy was an ideal community for commerce and industry. Located on the West Branch of the Susquehanna River, Muncy developed a thriving lumber industry complete with saw and planing mills. Timber raftsmen moving logs down the Susquehanna to the Chesapeake River often stopped at Muncy. They frequented the taverns and hotels, and certainly kept area distilleries in business.

The West Branch Canal became a great business thoroughfare, and its chief exports locally were hogs, wheat, flour, lumber, leather, and whiskey. At the time, there were 13 distilleries in the area with an output of 1,500 gallons per day. The canal ended in town at the Muncy Woolen Mills. Nearby, Muncy's Main Street began to fill with shops and industry.

There were carriage makers, an iron foundry, broom makers, dry goods stores, drugstores, a newspaper office, hotels, restaurants, and even an opera house whose second floor held the town's billiard room. A hospital was also established. If Muncy had a "Golden Era," this pre–Civil War period was it.

When the railroad eventually replaced the West Branch Canal, the Reading Railroad installed a depot in Muncy. Several of the postcards herein contain messages that mention train travel.

Some of the more popular and artistic postcards of this era are tradecards. These advertising cards were issued before 1900, and storekeepers gave them away in products or with the purchase of a product. One of the most aggressive merchants in Muncy to use these cards was W. H. Harman, who sold boots and shoes. These cards were whimsical by nature and often featured children or animals.

The fourth chapter, The River, contains many of the earliest postcards. These cards predate most of the images in this book, as the majority were manufactured prior to 1900. The West Branch of the Susquehanna River and its surrounding mountains were irresistible to early photographers. By including area bridges, in particular railroad bridges, photographers were able to localize their postcards. Images of the defunct West Branch Canal are included in this chapter, and some of the more interesting cards feature the Muncy Aqueduct, Lock No. 20, the Muncy Dam, the towpath, and the tree-lined canal.

More interesting than the images, however, are the messages many of these postcards convey. Some are written by children. The writers' inaccuracies have been retained since they add a charming colloquial theme.

There are also sad messages. In one instance, there is a mention about a girl who was killed by a cannonball. While researching newspapers of September 1907, it was discovered that the cannonball that killed 15-year-old Helen Lloyd was not a weapon, but a train that swept by her on the tracks at Muncy. The vacuum created by the speeding train sucked Lloyd against it, then flung her lifeless body 40 feet away. Her brother, who had been fishing with her only minutes earlier, was saved by lying between the train tracks. Her funeral was attended by her classmates and mentioned on a postcard by a sad, lonely young girl who wrote to her aunt.

Other messages are lighthearted. On one postcard, the writer teases a young boy and asks if his new teacher had "whipped" him yet. In another missive, a young man brags about eating "twelf" eggs.

This postcard history may capture less than 50 years in Muncy's history, but it is a history filled with heart and prosperity.

One

SOCIETY

The borough of Muncy, with a population of about 2,500, is blessed with a most dynamic historical society.

Founded in 1936 by Dr. T. Kenneth Wood, the Muncy Historical Society and Museum of History began as the dream of Bessie Clapp, whose husband's family had settled here. For several years, the widow offered the dilapidated house to Wood on the condition that he establish a local historical society. At the time, Wood served as president of the Lycoming County Historical Society. He doubted that Muncy could—or would—support a historical society. After his term with the county historical society, Wood retired to his medical practice and revived the *Now and Then* historical magazine that was created by Jeremiah M. M. Gernerd in 1868.

After the 1936 flood nearly destroyed the house, Clapp again visited Wood. This time, she offered a bribe. "I was again called upon by my temptress. She carried a sagging knitted reticule, which she set down by her side with a sound resembling the crash of twenty pounds of hardware," Wood later recalled. "I made the fatal mistake of asking her what she had in the bag. She replied that she and her sons had removed twenty pair of small brass door knobs from the house, and now intended to hand the building over to a wrecking crew.

"'But to take away the door knobs,' I said, 'would be sacrilege.' Indeed, they were the only things I liked about the old ruin. Brightly and eagerly she replied that, if I would accept the gift and her conditions, she would give me the knobs then and there. At last she had touched me in my most vulnerable spot. Before I knew what I was saying, I had capitulated and undertaken what I knew was a Herculean, if not impossible, task, just for forty pieces of brass—not silver."

Since then, the Muncy Historical Society has admirably preserved the town's heritage.

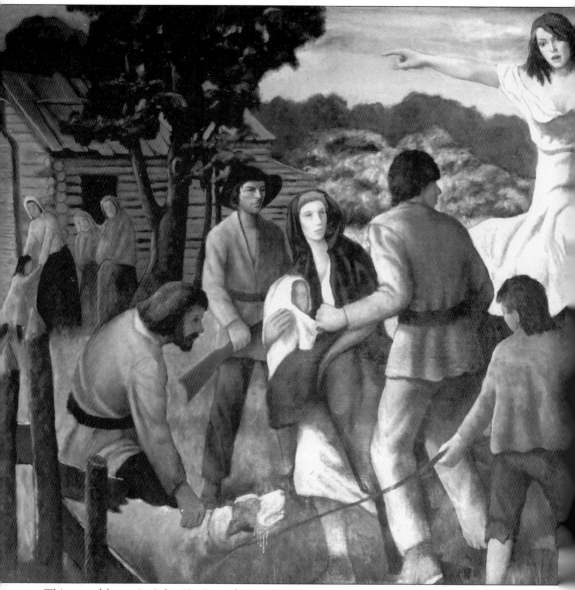

This mural by artist John W. Beauchamp is in the Muncy Post Office and depicts the brave pioneer Rachel Silverthorn, Muncy's "Paul Revere," who rode through the Susquehanna Valley warning settlers of a raid by Native Americans. Evacuating the countryside was not an easy

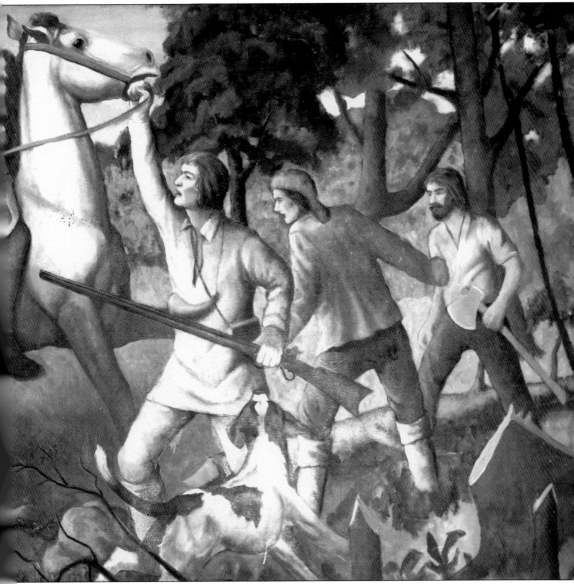

task. Hastily constructed rafts carried women and girls, while men and boys walked the shores, driving cattle and warding off the Native Americans. Rachel Silverthorn rode into history in 1778 and was never heard from again.

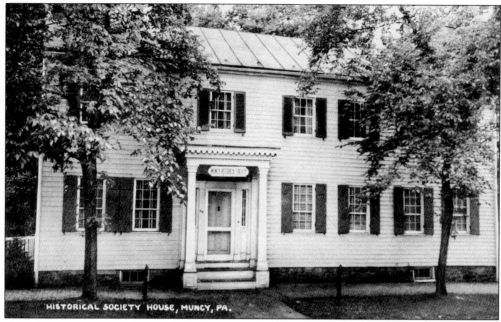

Plans to develop the Muncy Historical Society and Museum of History began in 1936, directed by Dr. T. Kenneth Wood, a native son steeped in history and gifted with talents for meticulous research, literary style, and executive ability. Bessie Clapp donated the Thomas Clapp home, the birthplace of her husband, H. Forest, to the people of Muncy as a memorial.

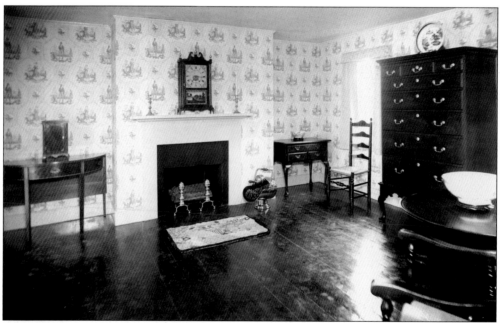

Before the Muncy Historical Society opened, volunteers scourged the town, borrowing furniture and artifacts to display in period rooms. At its dedication in 1938, commemorative postcards were sold of each room. This postcard shows the living room of the historic house.

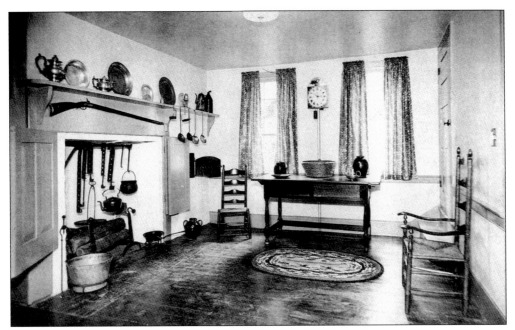

The Colonial kitchen was another exhibition room in the Muncy Historical Society at its dedication. Although the other rooms were later dismantled and items returned to their owners, this Colonial kitchen has remained similarly furnished in authentic antiques.

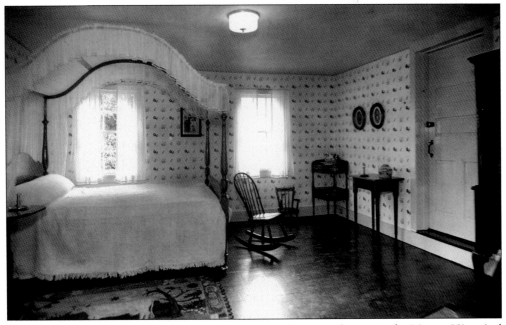

This commemorative postcard shows a bedroom, another period room in the Muncy Historical Society, at its dedication in 1938. The restoration of the historic house cost $9,000.

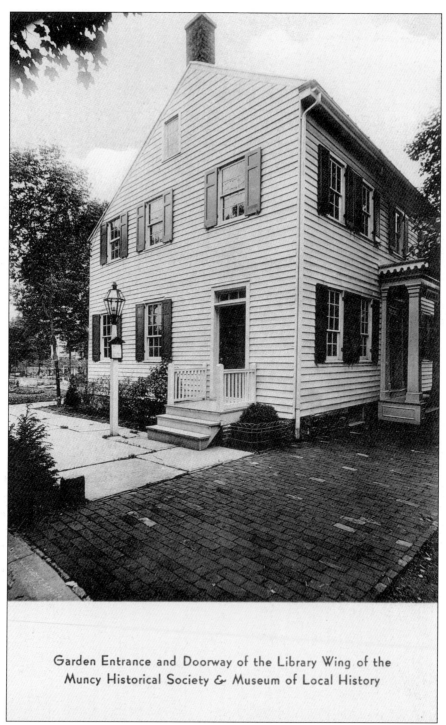

Garden Entrance and Doorway of the Library Wing of the
Muncy Historical Society & Museum of Local History

A side entrance led to the library wing of the Muncy Historical Society in 1938. The society's building was restored by skilled craftsmen under the sponsorship of the Works Progress Administration. Federal funds also financed the local garden club's landscaping activities.

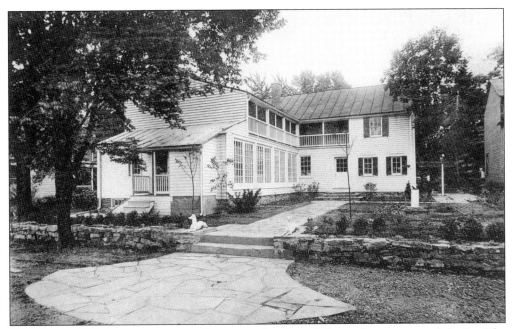

The backyard of the Muncy Historical Society often is used for outdoor events and picnics. The concept of a historical society became a reality with an invitation that read, "Dr. and Mrs. T. Kenneth Wood cordially invite you to be present at the organization party of the Muncy Valley Historical Society and Museum at their home in Muncy, Pennsylvania, on the evening of September 17, [1936], at 8:00 o'clock."

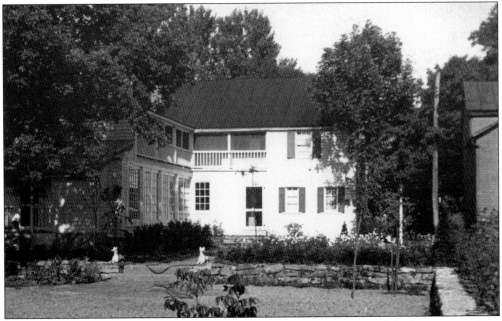

The twin greyhound statues in the formal garden of the Muncy Historical Society were on loan and later were returned to the Crawford family. Part of the society's mission is to sponsor exhibits each year and to display local items borrowed from private collections and family heirlooms along with museum accessions.

The first Baptist Church in Muncy was organized on June 24, 1841, with 28 constituent members. The Reverend J. Green Miles served as the first pastor. This church was completed and dedicated in March 1843.

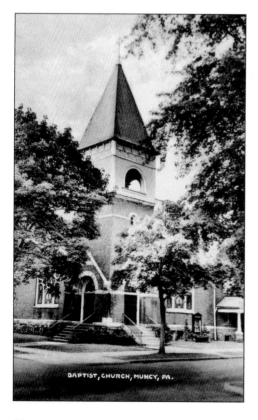

Area churches are a popular subject for postcards. Here is the Muncy Baptist Church, located at the corner of Penn and Market Streets.

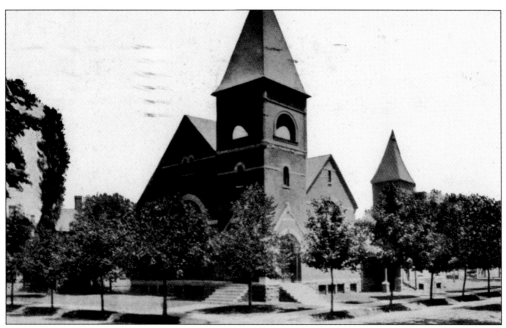

This postcard of the Muncy Baptist Church was sent on February 6, 1922, to Miss Amelia Heiser of Lewisburg. The message reads, "Dear Aunt. I look you did not write me. I will let you know us moved 339 Walnut St. We live 397 Susquehanna. I went to work at Muncy Pa. I am not work this week. I will paint rooms our house tomorrow. Your nephew, George Heiser."

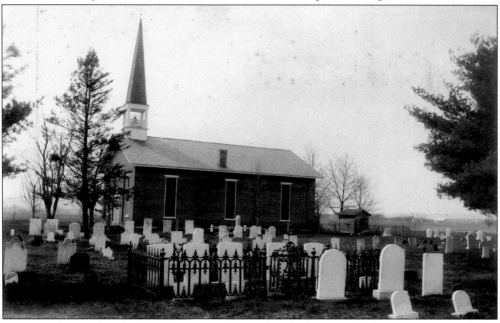

Known as the "mother church" of Lycoming County's Lutheran community, Old Immanuel Church opened its doors to other denominations in its early years. German Reformed, Episcopalians, and Presbyterians all met for church services in the earliest edifice, built in the latter part of the 18th century. That original church was replaced in 1832, and the current brick structure was built in 1869.

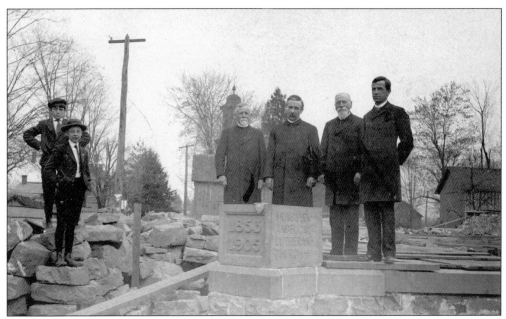

Two unidentified boys pose with clergy during the April 29, 1906, setting of the cornerstone for the new St. Andrews Evangelical Lutheran Church in Muncy. From left to right are the Reverend J. H. McGann, president, Susquehanna Synod; the Reverend J. H. Baird, pastor, Trinity Lutheran Church, Hughesville; the Reverend J. M. Steck; and the Reverend W. F. Steck, pastor, Muncy.

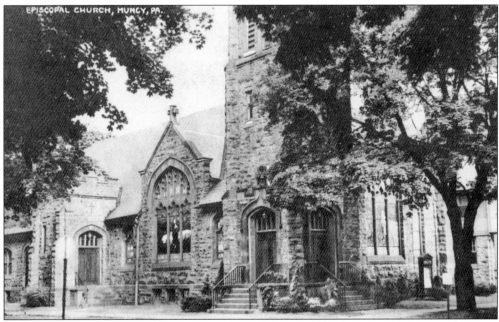

Although this postcard is identified as the "Episcopal Church, Muncy, PA," it is the Evangelical Lutheran Church. The Lutheran denomination is one of the oldest in and about Muncy, but no church was built within the borough limits until 1853. Previous to 1852, Lutherans worshiped at Old Immanuel Church in Muncy Creek Township.

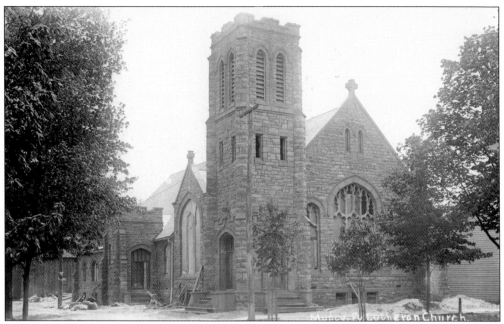

Some postcards conveyed sad news. This Muncy missive with the Evangelical Lutheran Church on the front was sent on September 8, 1907, to Mrs. Wm. H. Ellis, Hollidaysburg, Pennsylvania. It reads, "Dark and rainy. Papa did not come last night, so I'm alone. Called at Aunt A last even. Nothing exciting here. Helen Lloyd was killed by cannonball, Friday. Love to all. E." The 15-year-old Lloyd was walking home after fishing with her brother and crossed the train tracks just as a train was coming.

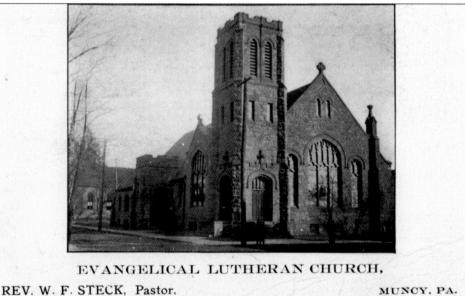

EVANGELICAL LUTHERAN CHURCH,

REV. W. F. STECK, Pastor. MUNCY, PA.

This Muncy postcard of the Evangelical Lutheran Church, where the Reverend W. F. Steck was the pastor, was sent on March 17, 1908, to Mrs. S. A. Bastian, Montgomery. It reads, "Dear Cousin, We will be down at your place this evening or tomorrow morning. If we come this evening, we will come on the five train. Good bye. From your cousin, Harris Huffman."

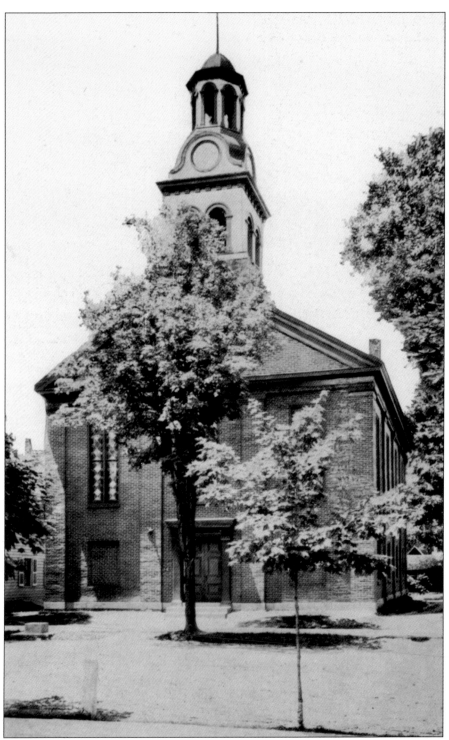

The first Methodist sermon was preached by the Reverend John Rhodes in an old log schoolhouse on South Main Street in 1821. In 1830, the first Methodist church was erected, and in 1854, it was displaced by this building at a cost of $7,000.

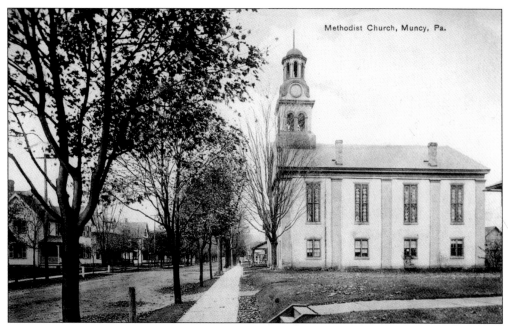

A postcard of the Muncy Methodist Church was sent on April 12, 1916, to Mrs. Norman Fogleman of Dewart, Pennsylvania. It reads, "Was to late for business in Milton. Did you see me go by on the train 10:30. The school is large this week. This is the street on which I board. S.B.S."

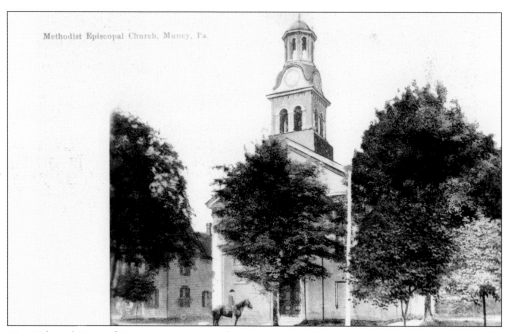

Mrs. Edward Rice of Watsontown, Pennsylvania, received this postcard of the Muncy Methodist Episcopal Church (with its completed steeple) on September 10, 1915. It reads, "Muncy Pa, Dear Aunt, they arrived home safe. have you got any more store butter. papa is better. he was very bad their for a while. TM.Fa."

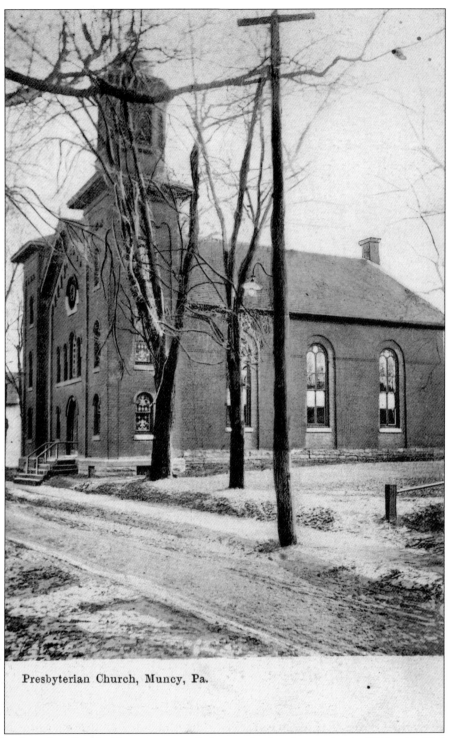

Presbyterian Church, Muncy, Pa.

The Presbyterian Church, Muncy, was regularly organized under state law in 1852, with 18 charter members. At times, the church had no pastor and was served occasionally by visiting clergy until April 1857, when the Reverend William Life was installed as pastor and remained until 1868.

The Presbyterian Church was organized in July 1834, at the borough school house with the Reverend Phineas B. Marr as the officiating clergyman. Thomas Hutchison and Dr. James Rankin were elected elders, and later the same year, they were ordained by the Reverend John Bryson. The Reverend S. S. Shedden was ordained as the first pastor of the church in 1835 and was dismissed in 1842. The Reverend John Smalley served from 1843 until July 1850.

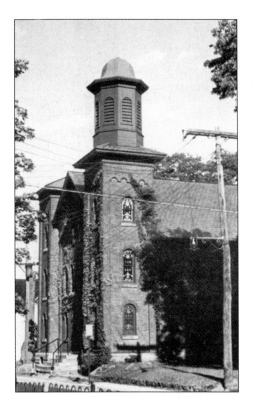

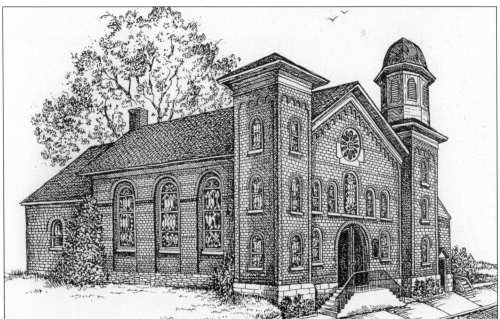

This postcard is one in a series of "Historic Muncy" by artist Judy Tamagno. It is a pen-and-ink drawing of the Muncy Presbyterian Church, which dates from around 1835, at Penn and Washington Streets. A Presbyterian house of worship was erected and dedicated in 1835. It was enlarged and improved in 1859 and rededicated in 1860. A parsonage was built in 1875.

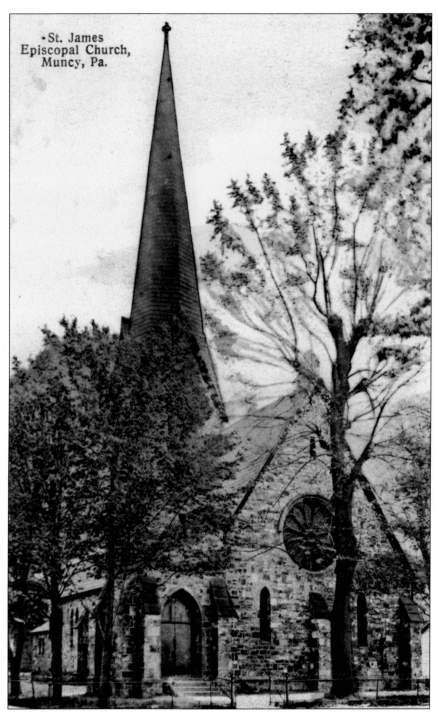

This postcard of Muncy's St. James Episcopal Church was sent on January 13, 1911, to Mrs. Edward Peterman, Jamison City, Pennsylvania. It reads, "Dear Nellie, I received your card but you did not say if you and Edd are a going move down or not. David Frey would like to know if Edd are coming down to. I work for him and right way and let us know. Are horse are better. From Aunt Mary."

St. James Episcopal Church was built in 1858 on South Main Street. The original chapel in the rear was built in 1832. Here is another "Historic Muncy" pen-and-ink drawing by artist Judy Tamagno. The church was built under the direction of Sarah Hall, a wealthy parishioner, and was designed by the well-known architect Richard Upjohn.

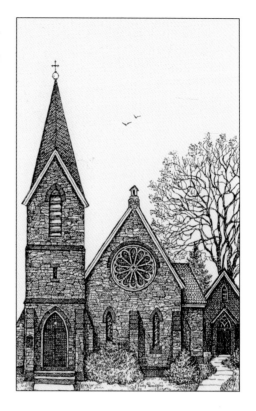

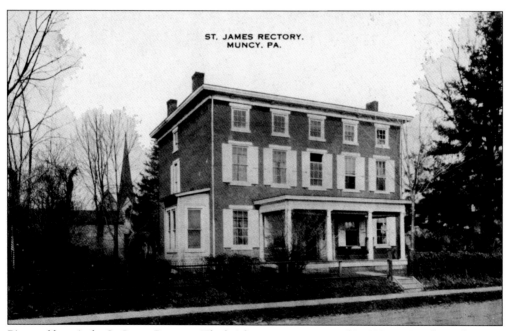

Pictured here is the St. James Rectory. The brick rectory was erected in 1856 on South Washington Street. Across the street is the old parish graveyard, abandoned in 1880. Eighteen graves were never moved to the Muncy Public Cemetery.

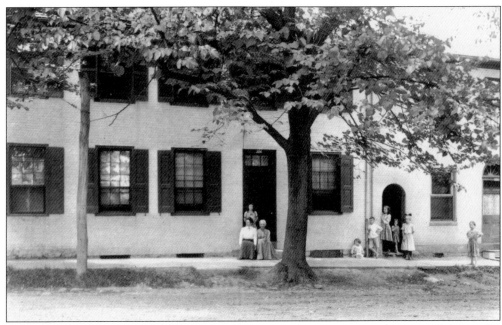

Women and children rest outside the Muncy Seminary, opened in 1841 for young ladies under the direction of Anna Wynkoop, who was assisted by her sister, Belinda Smalley. At one time, Rose Elizabeth Cleveland, sister of ex-president Grover Cleveland, was employed as a teacher in Muncy.

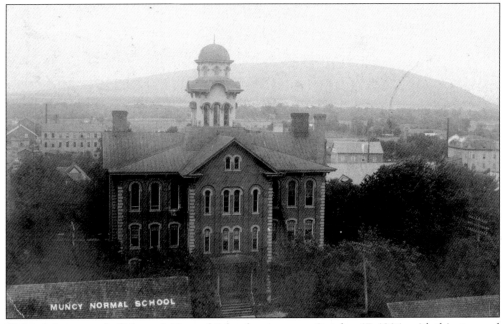

MUNCY NORMAL SCHOOL

This scenic postcard of Muncy's Normal School was sent on October 17, 1906, with this stamped address: "William H. Ellis, Lumber, Muncy, Pa. Sent to Miss Margaret Moore Ellis, c/o Roy Saxton Moore C.E., 37 Main Avenue, Elmhurst, L.I., N.Y."

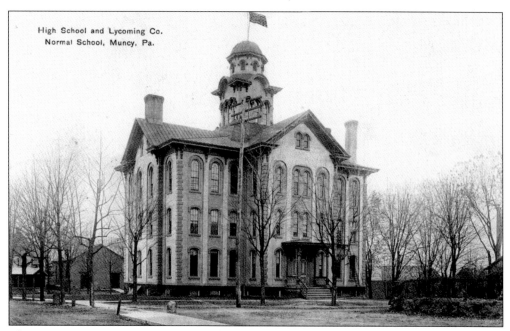

The Lycoming Institute was organized in Muncy in 1863. It was the first school of this type where local and district institutes were held. The school existed for about 60 years, and many prominent people were students or instructors there. This postcard was sent on August 10, 1911, to Miss Bertha Rump of Montgomery, by "Huddah."

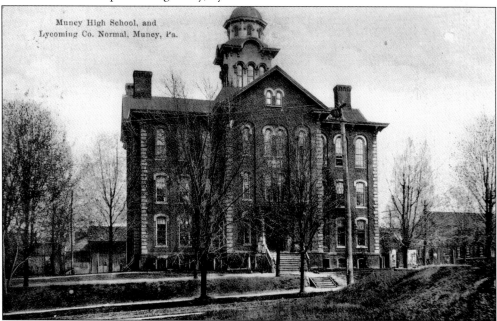

This postcard, titled "Muncy High School and Lycoming Co. Normal, Muncy, Pa." was sent to Miss Laura Billmeyer of Turbotville, Pennsylvania. It reads, "Be sure and come out on Friday night. I will look for you. I suppose you are glad to get back again. Ellen." Unique in the history of education at the time, the Normal School of Muncy was a pioneer of teachers's institutes that became popular throughout the United States during the early 1900s.

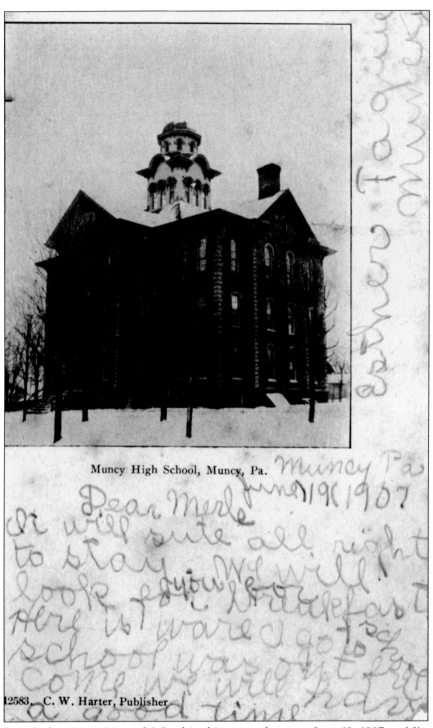

Muncy High School, Muncy, Pa.

12583. C. W. Harter, Publisher

Snow shrouds the Muncy Normal School in this postcard sent on June 19, 1907, to Miss Merle Bastion of Montgomery, from Esther Fague. "Dear Merle, It will sute all right to stay. We will look for you for breakfast. Here is ware I go to school. School was out Fri. Come we will have a good time."

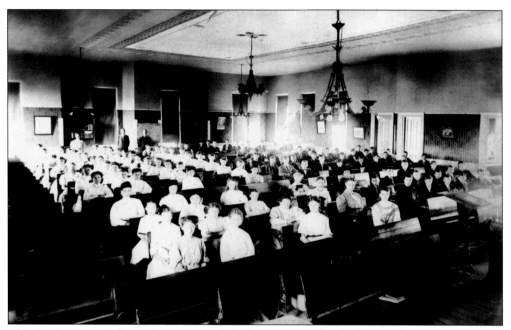

This 1907 postcard shows the interior of the Muncy Normal School, at the corner of Market and High Streets. At the time, the Muncy public school was on three floors. The first two floors held the grade school. The third floor was a single room, and all high school classes were taught there. Note how the boys sat on one side and the girls on the other.

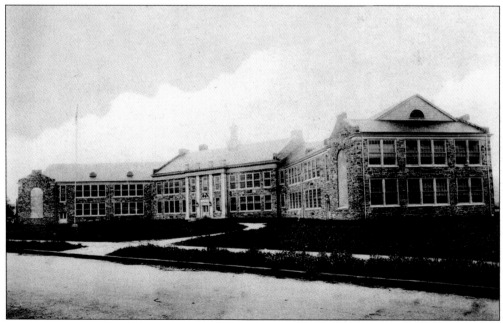

The first Muncy school board formed in 1834 with six directors. Classes were held at the old Central School, which was built in 1836. In 1931, the cornerstone was placed for the present high school, which is shown in this postcard.

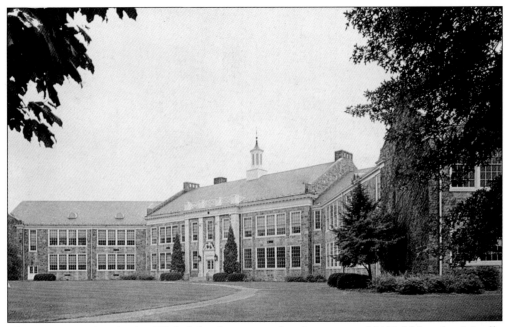

The Muncy Junior, Senior High School was completed at a cost of $121,000 and originally housed grades 1–12.

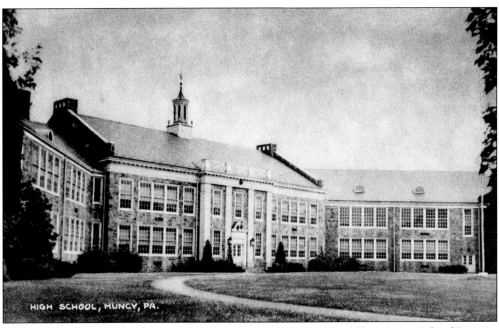

Muncy Junior, Senior High School is located on West Penn Street. The Muncy School District officially formed in 1964, and the high school presently serves students in grades 7–12.

This monument at the north end of Muncy is a tribute to Capt. John Brady, who was ambushed and killed on his way home from Fort Muncy on April 11, 1779. Brady was a soldier, then a ranger and scout. During the Revolutionary War, he served with the 12th Pennsylvania Regiment, which fought with Gen. George Washington at the Battle of Brandywine.

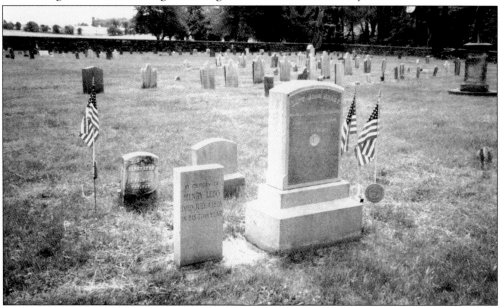

The tombstone on the right marks Capt. John Brady's grave at Hall's Station Cemetery. The smaller stone to the left is for Henry Lebo, a soldier who served with Brady. In 1776, Brady brought his family to Muncy manor, where he built a semi-fortified log house, known as Fort Brady. His son James, who was attacked by Native Americans, survived their scalping for several days before dying of his wounds. Samuel, another of Brady's sons, became a renowned scout and military leader on Pennsylvania's western frontier.

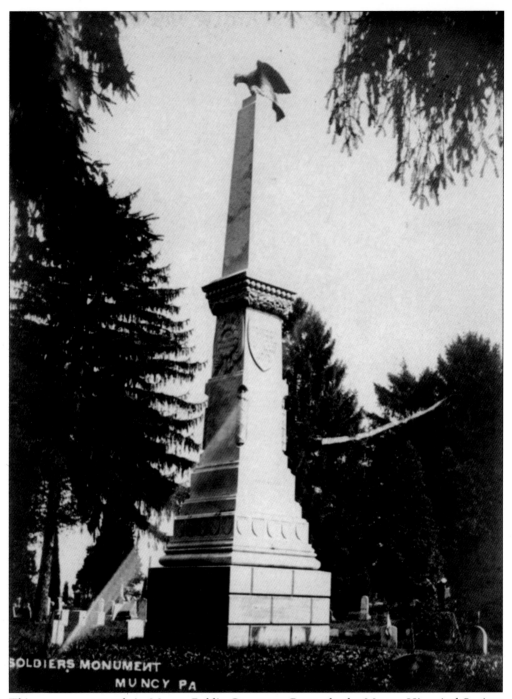

SOLDIERS MONUMENT
MUNCY PA

This monument stands in Muncy Public Cemetery. Recently the Muncy Historical Society relandscaped the monument to include the "Circle of Heroes"—paving bricks bearing the names of 64 additional Civil War casualties whose names were omitted from the original monument.

Two

NEIGHBORHOODS

Muncy, often called the "Williamsburg of Pennsylvania," has many historic homes built in Victorian, Georgian, and Federal styles.

The beauty and charm of the town is the focus of the Muncy Historical Society's annual Historic Homes Tour. In 2006, the society added showcase gardens to the tour.

The historic society building also is unique, and each year it is part of the Historic Homes tour. It is a two-and-a-half-story, seven-bay-by-three-bay frame building in the Greek Revival style. It features an original beehive oven in the Colonial kitchen. In addition to a model of Fort Muncy created by the members of the WPA in 1938, the society also maintains a full collection of significant artifacts of Muncy's past.

Muncy also is proud of its churches, in particular the St. James Episcopal Church. This example of Gothic Revival was designed by architect Richard Upjohn. Born in England, Upjohn came to the United States in 1829. In 1839, he was commissioned to rebuild Trinity Church in New York City, which he finished in 1846. He carefully modeled it on English examples and inaugurated a new phase in the Gothic Revival that is reflected in Muncy's St. James Episcopal Church.

St. Andrews Evangelical Lutheran Church features a square three-story bell tower topped with battlements, a symmetrical floor plan interrupted by a number of small side bays, and Tudor arches enhancing the various entrances. The church was designed by M. I. Kast and constructed using stone from the West Branch Canal aqueduct.

One of Muncy's oldest brick dwellings, the Riebsam House, is an example of Colonial-Federal architecture. Some of its unusual features are a fan-light doorway with eight panels, a Palladian window on the third floor, and several finely windowed roof dormers. The home must be painted to preserve its soft brick exterior.

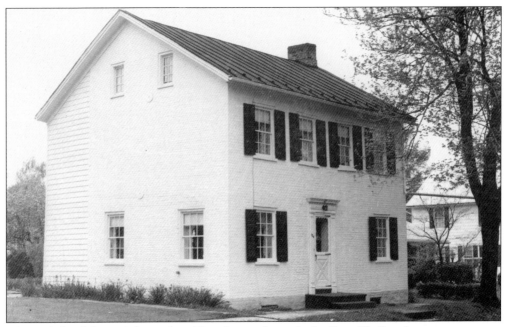

This early brick home is located on New Street, formerly the Danville Road.

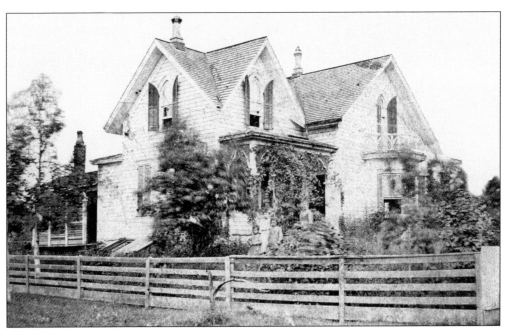

Children pose outside of this house owned by Jessie Shoemaker at 300 North Main Street. The Shoemakers were a pioneer family descended from Mary Scudder, the first white female child born north of Muncy Hills when the area was settled in the 1700s.

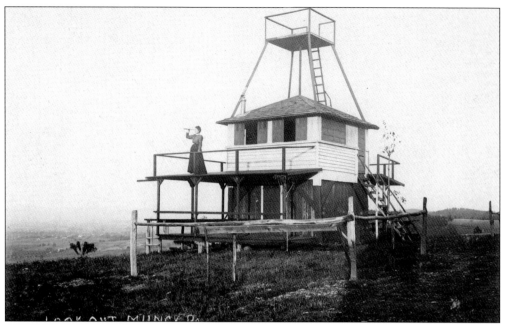

Muncy's McMichael Look Out was a popular spot for scenic views during the 19th and 20th centuries. This Muncy postcard was signed "Waldron."

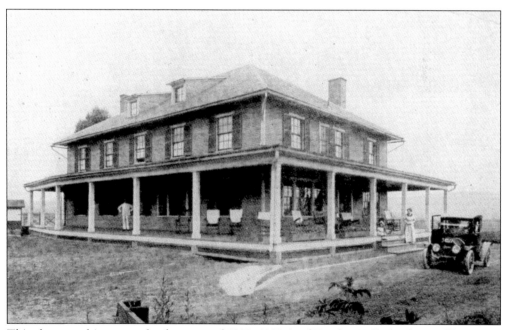

This photographic postcard, taken around 1910–1915, is of Hartley Hall Hotel in Hall's Station, a hamlet outside of Muncy. The area is part of the large tract of land originally owned by Samuel Wallis and then the Hall family, in whose honor Hall's Station was named. It also contains Hall's Cemetery where many original settlers are buried.

One of the earliest homes in the area is the John Adlum house, located on Narber Fry Road in Pennsdale. Adlum, a land surveyor, wrote the first book on the art of growing grapes, and he is credited with introducing the Catawba grape vine.

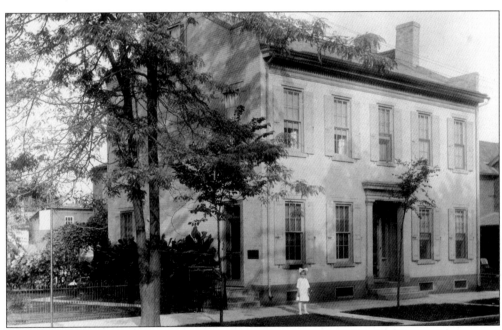

This house at 26 North Main Street was built by Muncy merchant Daniel Clapp, who operated a Port Penn sawmill. Other owners include Dr. T. Kenneth Wood, and Alfred and Jane Jackson. Clapp came to Muncy from Northumberland County relatively poor in 1843 and worked hard at his mercantile business until he began working in lumber. He served as a burgess of Muncy in 1865.

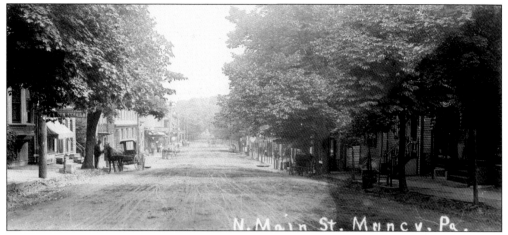

Here is a 19th-century vista of North Main Street in Muncy that shows unpaved roads traversed by horse and carriage. On this type of postcard, the message was written on the front and the address on the back.

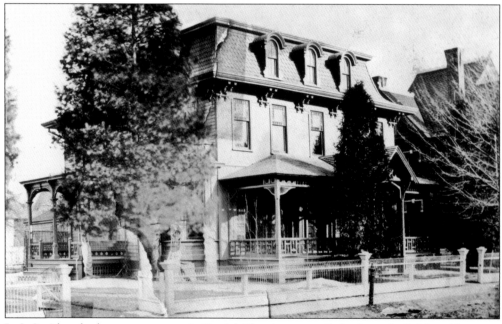

L. S. Smith, who became a partner in Daniel Clapp's mercantile business, built his residence on North Main Street. Smith later built a three-story brick commercial building on the corner of Main and Water Streets. The Smith home was converted into a youth center under the financial auspices of Margaret Brock, then torn down around 1954 and replaced with a gas station.

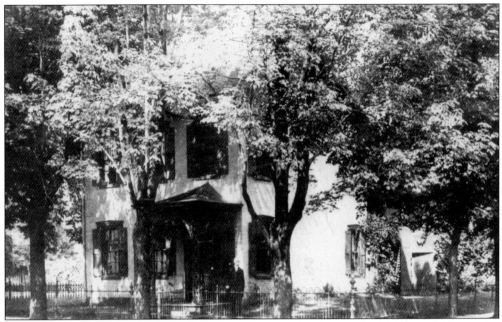

John M. Bowman, who was captain of Company G, 11th Regiment, when Lycoming County mustered for the Civil War in 1861, owned this historic brick house on the northeast corner of Main and Penn Streets. He was married to Eleanor Cockey Bowman. The house was torn down in 1908.

This house, on the northeast corner of Main and High Streets across from the post office, once belonged to Simon Schuyler, who was a justice of the peace. Posing in this photograph are Mrs. Lewis Evans Schuyler, Edwin Schuyler, Emma Schuyler, who was married to John D. Peterman, and Rosetta Schuyler Montgomery.

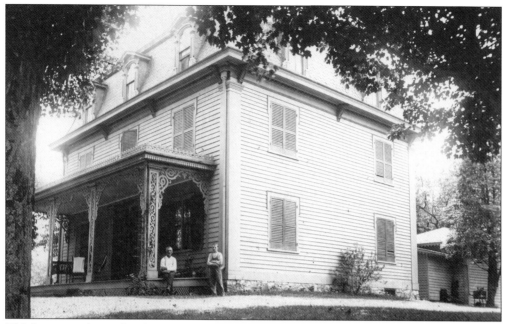

This home was located at the corner of Penn Street and Route 405, at the "Y." John Ritter, left, sits on the porch. The Ritter family members were pioneers in the region.

In the 1930s, Muncy had become a quiet town, as its lumber boom was over, the canal was defunct. This scene is looking east at the corner of Main and High Streets. Painter's Drug Store, on the right, was torn down for the new post office.

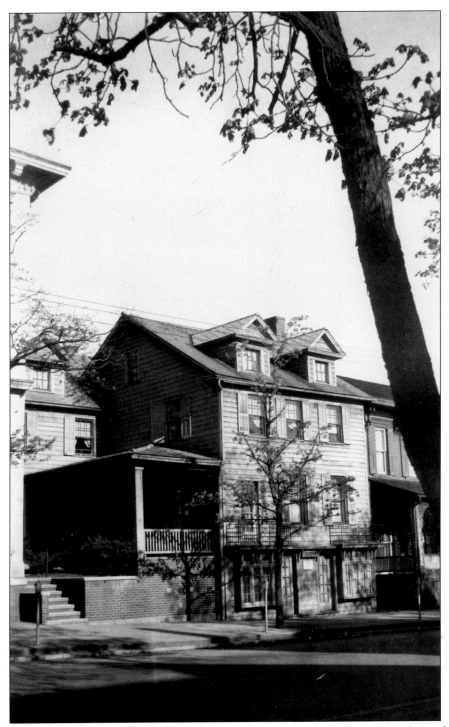

Ida Rogers's house on South Main Street was restored in 1952. She was the daughter of John W. Rogers, who for many years worked with Northern Central Railroad as a brakeman. In 1876, he became conductor and remained until August 1, 1883. He left to assist in building a tannery in Ralston.

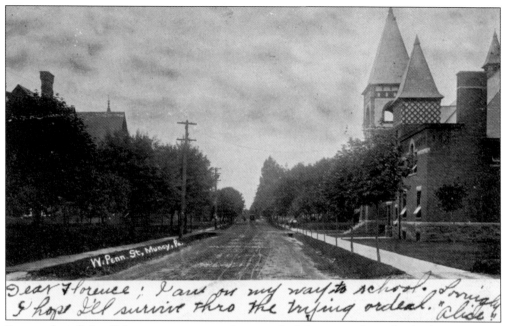

Even students living 100 years ago were not always excited about attending school. This postcard of West Penn Street in Muncy was sent on May 29, 1907, to Miss Florence Strouse in Montgomery, Pennsylvania. It reads, "Dear Florence: I am on my way to school. I hope I'll survive thro the trying ordeal. Lovingly Alice."

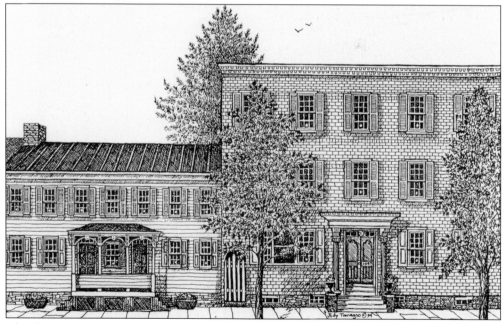

This "Historic Muncy" postcard by artist Judy Tamagno is of the Muncy Library, which dates to 1821, and the Muncy Valley Building, built in 1826, on Main Street. The public library was founded in 1938 by the Tuesday Study Club and was housed in a room at the Muncy Historical Society building. It was operated by club members for 25 years before a librarian was hired and it moved to its current location in 1965.

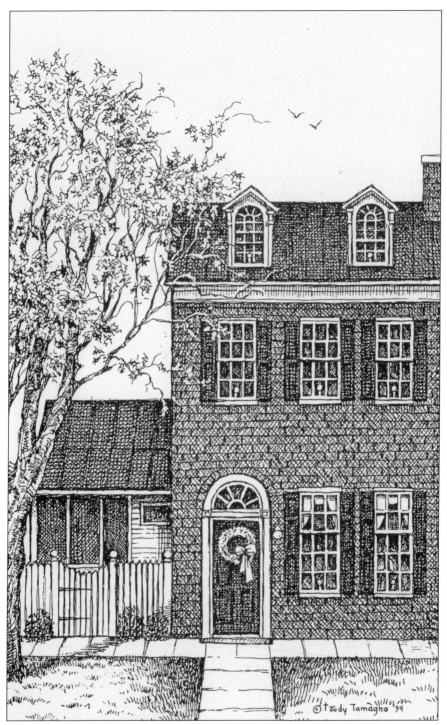

This "Historic Muncy" sketch by artist Judy Tamagno is of the Riebsam House, one of Muncy's oldest brick dwellings, located at 210 South Main Street. Although Johan Sebastian Riebsam and five of his sons came to Muncy in the 1790s, the original section of this home was not built until 1810. As their fortunes and family grew, the Riebsams added the front section some 10 years later.

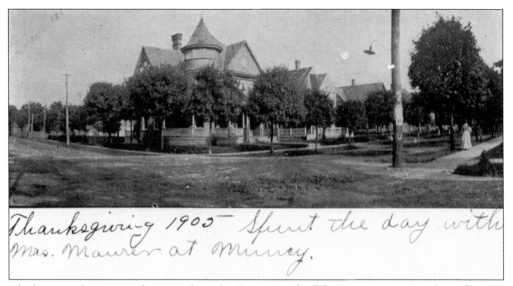

Thanksgiving 1905— Spent the day with Mrs. Maurer at Muncy.

The house at the corner of Penn and Market Streets was built by L. B. Sprout, president of Sprout Waldron Company. This postcard reads, "Thanksgiving 1905—Spent the day with Mrs. Maurer at Muncy."

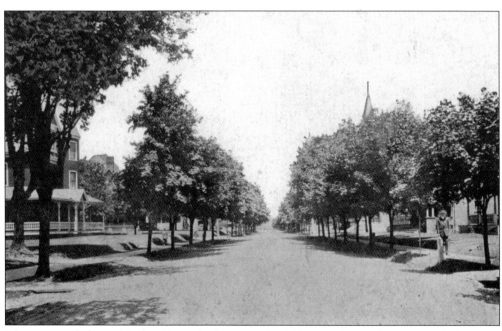

This postcard shows Market Street looking south. Although the road is unpaved, there are sidewalks and trees lining the boulevard.

The Thomas Clapp house is now the Muncy Historical Society. Also a merchant, Thomas Clapp was not as prosperous as his brother, Muncy merchant D. L. Clapp. After the 1929 death of Forrest Clapp, this house was donated to the community to use as a historical society and museum.

Here is a view of the residential section of South Main Street. This postcard is addressed simply to "Margaret."

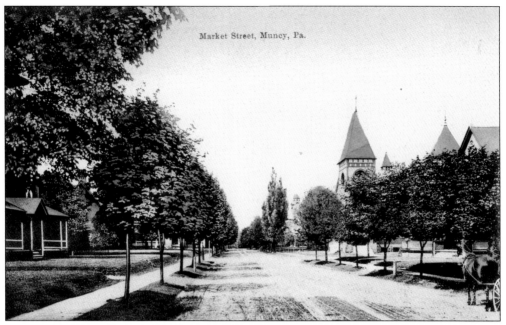

Market Street, Muncy, Pa.

A horse-drawn carriage makes its way down Market Street in Muncy in this early 20th century postcard. At right is the steeple of the Baptist Church.

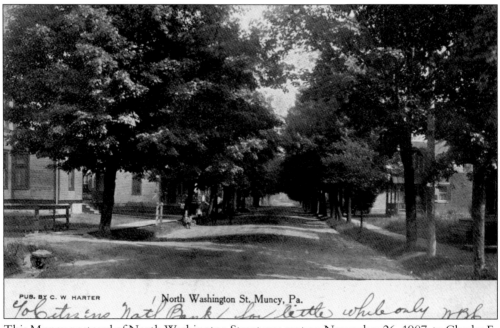

PUB. BY C. W HARTER North Washington St. Muncy, Pa.

This Muncy postcard of North Washington Street was sent on November 26, 1907, to Charles E. Koogle of Williamsport, Maryland. Its message is "To Citizens Natl' Bank for little while only, NBC."

Rose Hill was built by Joshua Alder, who was educated as a chemist and practiced his trade at his father-in-law's company, Lewis Glass Works, in Eagles Mere. While Lewis Glass Works flourished for several years, its owners soon found themselves in dire financial straits when their fragile product continued to shatter and break on the way off the mountain. When Alder left his position in 1817, he took up residence in Muncy and, in 1822, built the original brick section of this Federal-style home.

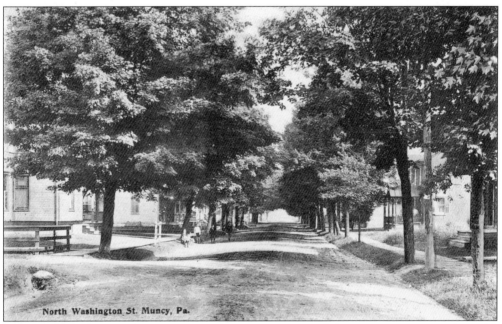

North Washington St. Muncy, Pa.

A postcard of North Washington Street, this missive was mailed on May 11, 1909, and sent by "Mary" to "Miss Mae Maneval, 1461 W. 4th St., Williamsport."

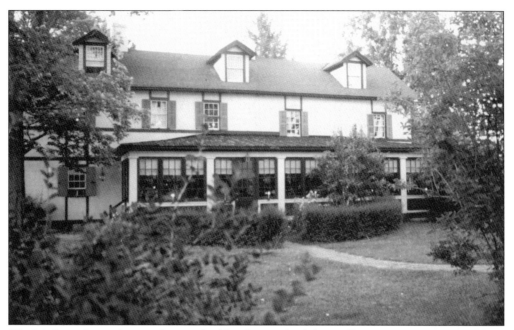

The McCarty house is one of Muncy's oldest homes, built by William and Mary McCarty who moved to Muncy from Bucks County. They raised 13 children here.

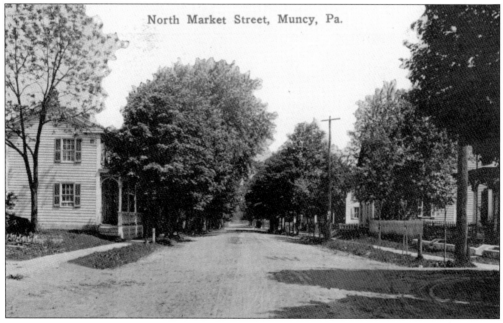

This postcard of North Market Street was sent on October 5, 1927, to Mrs. T. M. Mitchell of Ohiopyle, Pennsylvania. It reads, "Dear Mrs. Mitchell and all, we surely enjoyed the centennial at Baltimore and arrived here this morning. Will visit Evelyn next Thurs. or Fri. as we only stayed an hour in Philadelphia. Hope every one is well, Love Jean and Harry."

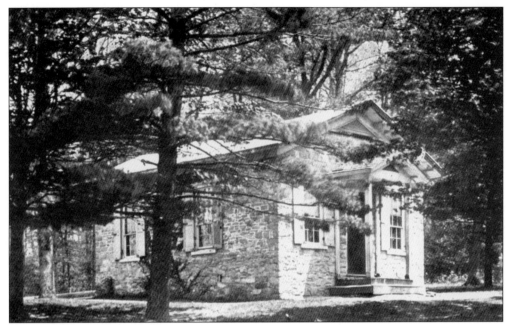

The Friends' School House in Pennsdale is one of the landmarks of Muncy Township. The house stands on a knoll a little to the west of the village. It is believed that the school opened before 1798.

The Friends' Meeting House in Pennsdale was built in 1799 to provide a place of worship for the numerous Quaker settlers of this region following the American Revolution. Ardent about education, the Friends built one of the first schoolhouses in the county. In the early days of the meetinghouse there were about 400 members living in the region. There is a small group that still meets in the stone house today.

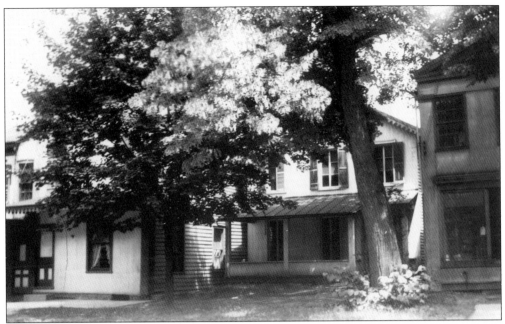

The 100 block of South Main Street was home of the *Muncy Luminary*, the borough's weekly newspaper. The *Muncy Luminary* was operated by William and George Painter and debuted on April 10, 1841. The newspaper was an outgrowth of the *Muncy Telegraph*, the area's first local paper that began in 1833. The *Muncy Telegraph* was published until March 1841, when it changed hands and was renamed.

Along Pepper Street, on a bluff overlooking the West Branch of the Susquehanna River, sits the homestead of Quaker William Watson. Built around 1800, the property is adjacent to the West Branch Canal and towpath undergoing preservation by the Muncy Historical Society.

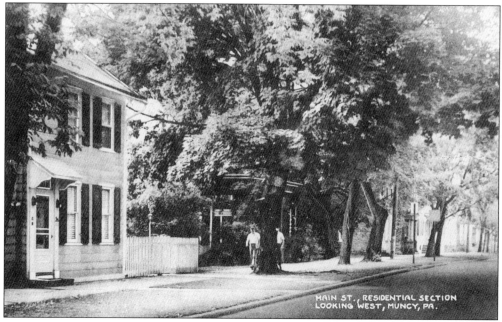

MAIN ST., RESIDENTIAL SECTION
LOOKING WEST, MUNCY, PA.

Taken around 1920, this photographic postcard is of a residential section looking north on Main Street.

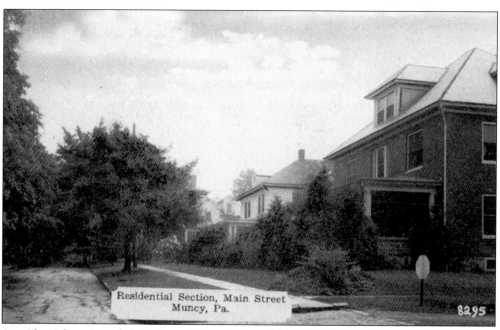

Residential Section, Main Street
Muncy, Pa.

8295

A residential section of Main Street is the subject of this *c.* 1925 postcard.

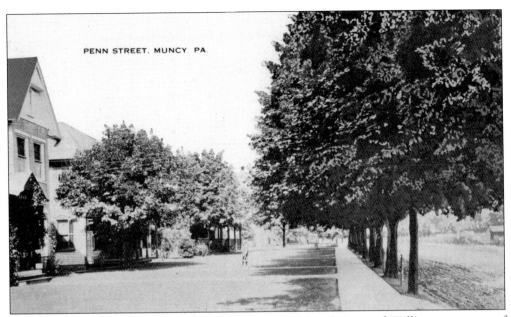

PENN STREET. MUNCY PA.

This postcard features Penn Street and was sent to Mildred Kurtz of Williamsport, care of Dr. Nutt, Private Hospital. It reads, "Dear Mildred, This is Sat. p.m. and we are all sure glad you are getting along so nicely. You will soon be able to come home, get well and fat like Ada G. Ha! Ha! Dorothy Price says 'Poor Milly, so sick up Williamsport.' I have so many pretty flowers I will send when I get a chance as I barely think I will get up as it is so hard to leave Dorothy. Aunt Lulu."

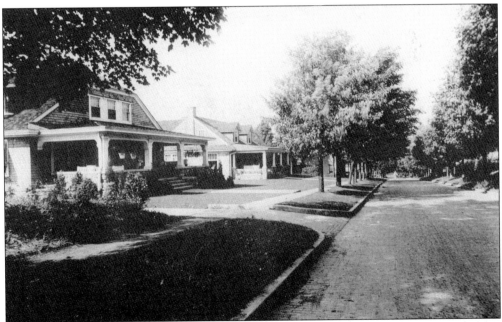

The arts-and-craft style, or the Craftsman Bungalow house, popular from 1905 to 1930, can be seen in this South Main Street postcard. These houses featured a low-pitched roof, wide eaves, and decorative braces. Generally one and a half stories, bungalows had a porch with square columns.

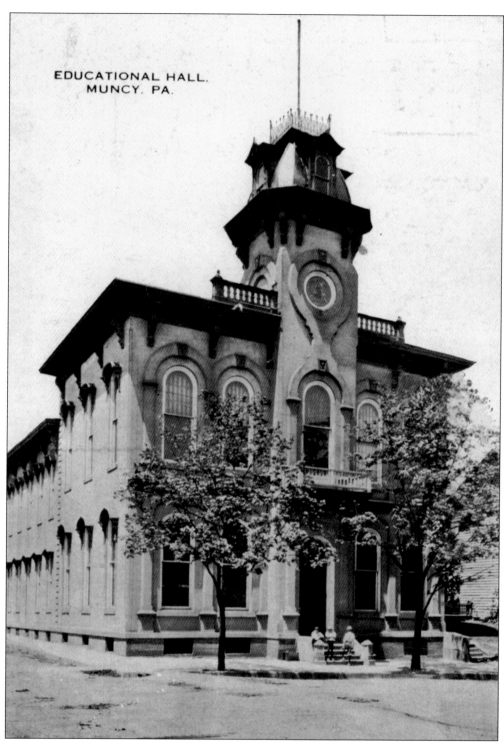

EDUCATIONAL HALL.
MUNCY, PA.

Penn Hall was built in 1874 by Joseph Nesbit to house the Lycoming Fire Insurance Company, which went bankrupt in 1881 because of the Great Chicago Fire. It was used for educational purposes from 1908 to 1936. This building is now known as the Margaret Waldron Building.

Three

BUSINESS AND INDUSTRY

Historic Muncy was an ideal community for commerce and industry because of its location on the West Branch of the Susquehanna River, the historic Susquehanna Trail, and the West Branch Canal.

In 1772, the newly formed Northumberland County needed a reliable road to the settlement at Muncy and to villages up the river. This road became the first upon which wagons could be used.

In the 1930s, portions of this road became the famous Susquehanna Trail. Locally it consisted of Pennsylvania Route 147 from Northumberland to Muncy, U.S. Route 220 to Williamsport, then U.S. Route 15 to New York. At the height of its popularity, thousands of people traveled this automobile trail daily, following the 450-mile ribbon of concrete to either Washington, D.C., or Niagara Falls.

Before the West Branch Canal, lumber raftsmen used the river at Muncy on their way to points south. But it was the canal, followed by the railroad, that enabled Muncy to grow by leaps and bounds. Throughout the nation, more than 4,000 miles of towpath canals were dug. In Pennsylvania, 1,356 miles of canals (more than in any other state) linked together cities, villages, factories, mines, and farms.

In 1834, the West Branch Division of the Pennsylvania Canal reached Muncy, bringing with it great potential for import and export, and business for the numerous merchants and taverns that opened to service passenger boats.

The neighborhood of Port Penn grew around the canal and, with it, Muncy. Manufacturing flourished, and the small business community expanded. Local carpenters worked in the Port Penn boat building facility, and hotels and taverns provided housing and food for boatmen, timber raftsmen, and canal travelers. Other occupations were represented here as well, including the blacksmith, saddler, miller, grocer and butcher, weaver, boot manufacturer, wagon maker, ice dealer, schoolteachers, masons, and general merchant.

When the railroad superseded the canals, these same businesses relied upon passenger trains for their livelihood.

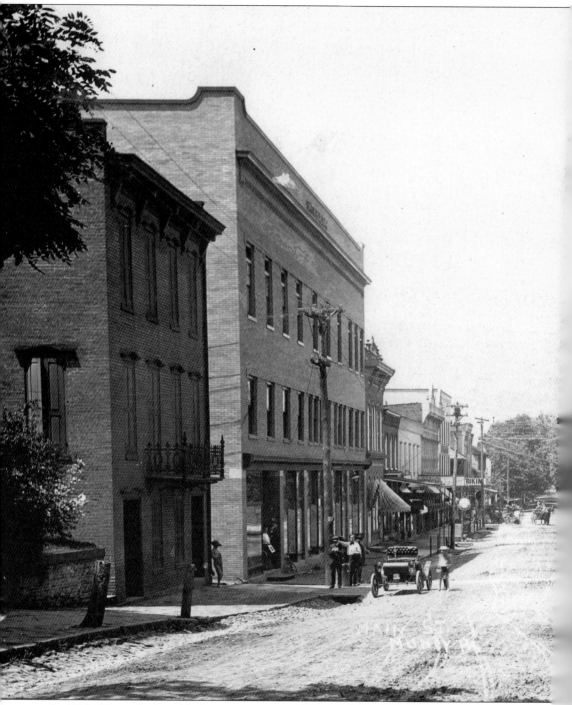

In 1900, Muncy's electrified Main Street was filled with shops and businesses, including a haberdashery, a livery, and an undertaker. In this postcard, a lone automobile is seen parked on the left. The town grew from a straggling village known as "Hardscrabble" to a more refined

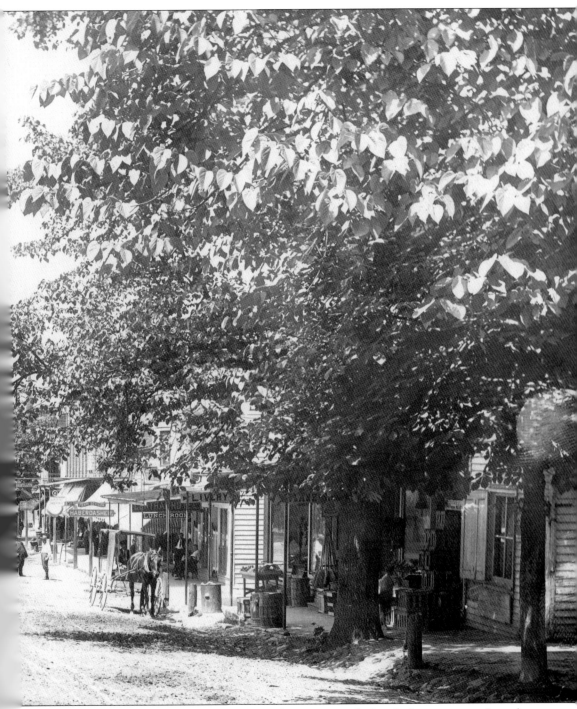

Pennsborough, then to Muncy, and thanks to the West Branch Canal, the town experienced a lumber boom similar to nearby Williamsport.

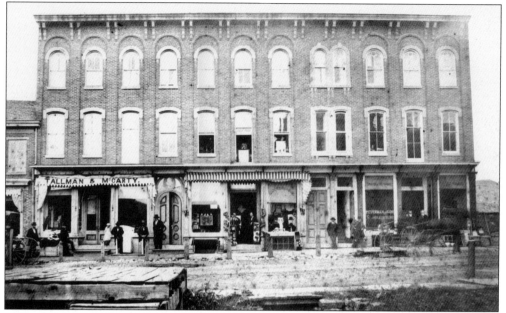

This 1876 photograph shows a three-story brick building on South Main Street in Muncy. The shop on the left, Tallman and McCarty, later became Tallman's. Both the Tallman and McCarty families were early settlers of the area. Early advertisements for Tallman and McCarty list them as dealers in "staple and fancy dry goods, notions, zephyrs, Germantown wool, and Mme. Demorest's Reliable Patterns."

Looking south from the corner of Main and High Streets, this photographic postcard was probably taken from Penn Hall. Pictured are, from left to right, Painter's Drug Store, Thornton Walker's Barber Shop (Moses Bell had his shop there at one time, too), an empty lot, and the Muncy Luminary newspaper office.

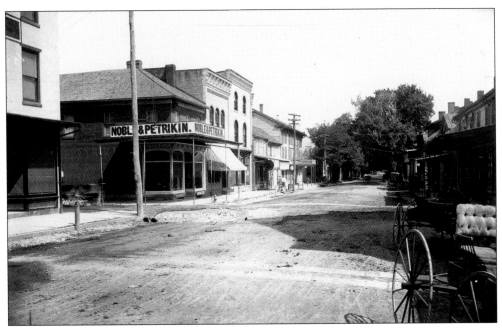

The Noble and Petrikin dry goods store, operated by E. R. Noble and William A Petrikin, was located on the northwest corner of Main and Water Streets. The main office of the Muncy Bank and Trust Company, located on this corner today, erected a new bank on this site in 1921.

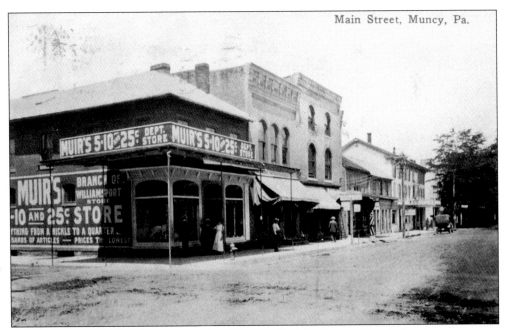

Here is the same corner looking north at Water and Main Streets. Muir's department store, a branch of a Williamsport store, had replaced Noble and Petrikin. This postcard was mailed on May 7, 1913, to Masters Paul and LaRue Lawrenson of Hughesville. It reads, "Hello boys, Do you (go) fishing these days? How are Regina, Mother and Father? Do you remember this store? Cora."

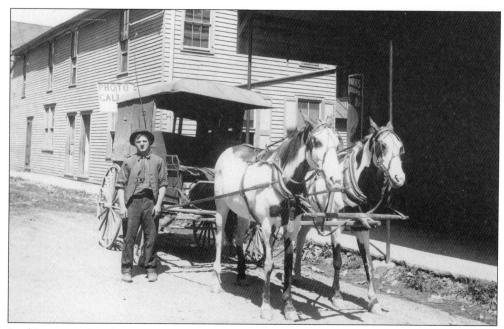

In this postcard, a driver waits by his horse-drawn wagon on Water Street. Behind him is a photograph gallery.

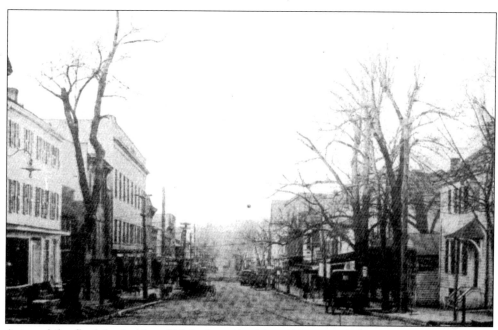

Automobiles flank both sides of Main Street in this *c.* 1910 Muncy postcard.

Two men in a buggy drive down the unpaved North Main Street in Muncy. The Crawford House is in the background. Notice the shoe shine chair in front of the hotel. The building originally was the Franklin Hotel, opened by John Shaffer in 1841.

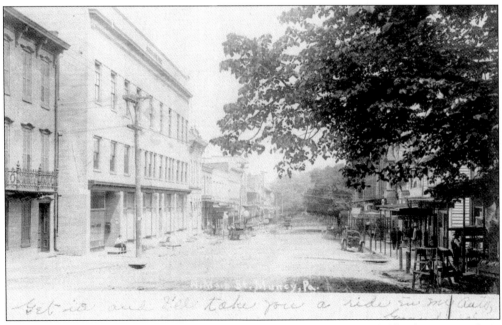

This early Muncy postcard of North Main Street reads, "Get in and I'll take you a ride in my auto."

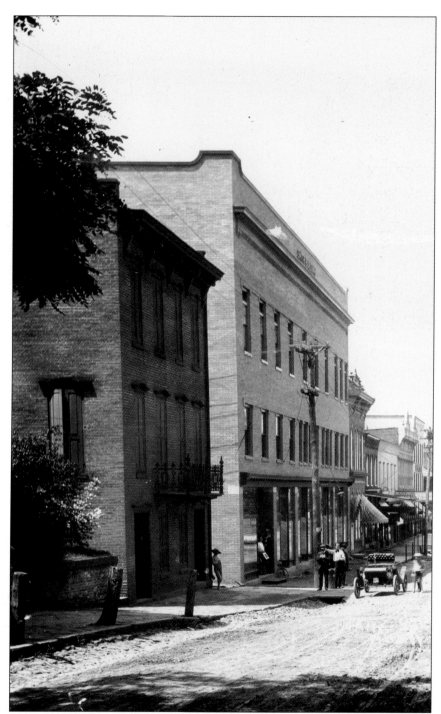

The brick home (far left) at 32 South Main Street, next to the three-story Smith Building, was built in 1875 by Baker Langcake after his first house burned in March 1875. Langcake served as burgess of Muncy in 1850. Born in Philadelphia, he moved to Williamsport and married Janet Hepburn, daughter of Judge William Hepburn. Then he moved his mercantile business to Muncy where he retired.

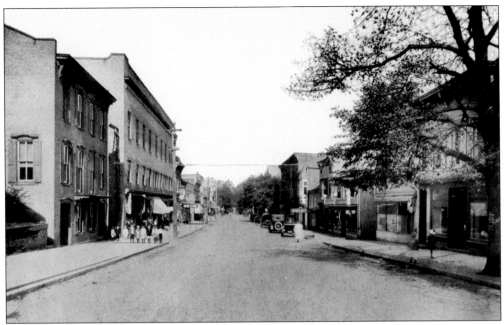

Schoolchildren line up on the sidewalk on Main Street near the Smith Building in this
c. 1915 postcard.

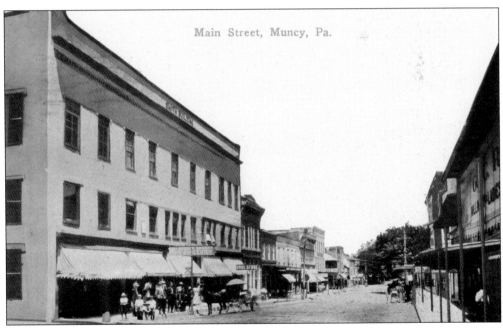

This postcard of the Smith Building and Muncy's Main Street was mailed on December 2, 1917,
to Brady R. Snyder, who was in the army and stationed at Camp Hancock in Augusta, Georgia.
It was sent from E. E. Meggs. At the time, the Smith Building housed Clarence Rogers Fine
Groceries and a drugstore.

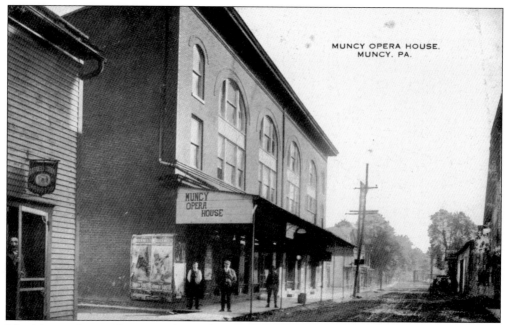

The Muncy Opera House was located on East Water Street. Several of Lycoming County's boroughs had opera houses where traveling opera companies and musicians performed. Often it was the only professional entertainment available in small towns and rural areas.

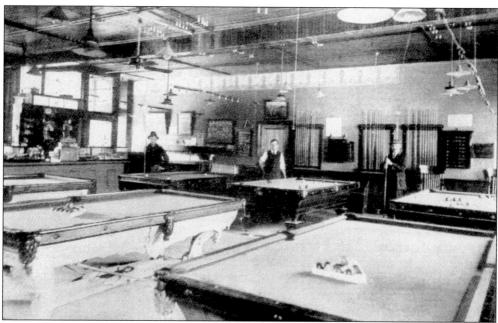

The Muncy Opera House also featured a billiard parlor. The American billiard industry was made popular by Michael Phelan, who emigrated from Ireland in 1850. Phelan wrote the first American book on the game and was influential in devising rules and setting standards of behavior.

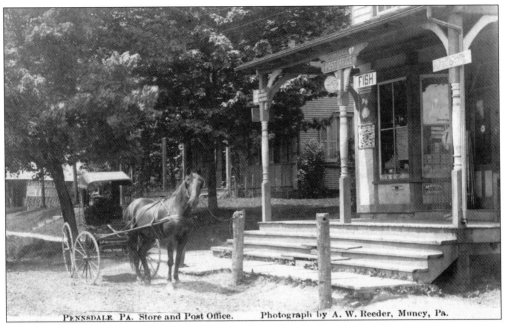

PENNSDALE. PA. Store and Post Office. Photograph by A. W. Reeder, Muncy, Pa.

A horse and carriage are tied to a hitching post outside the Pennsdale Country Store and Post Office in this photographic postcard by A. W. Reeder of Muncy. The postcard was sent to "Miss Margaret Waldron of Muncy." It reads, "Here is where I sent this from. M.G. (Ly Co)."

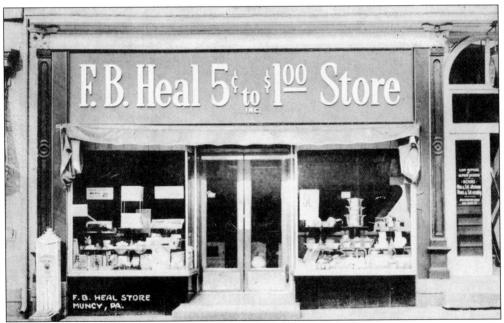

This postcard is of the F. B. Heal 5¢ to $1 Store, formerly on Main Street in Muncy. Stores like this sold discounted general merchandise and were patterned after Woolworth's. Known as five-and-dime stores, they were a fixture in American downtowns through the 1960s.

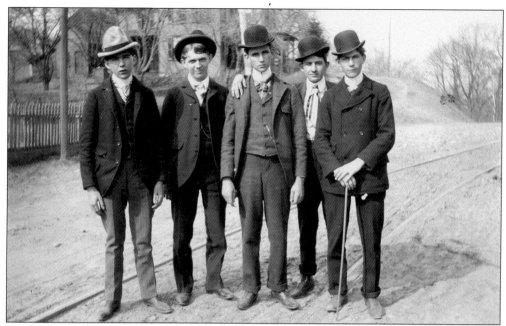

Young men "going to town" in Muncy are, from left to right, Archie Young, Sylvester Dunlap, Charles Henrey, Horace Weaver, and Edwood Gilbert.

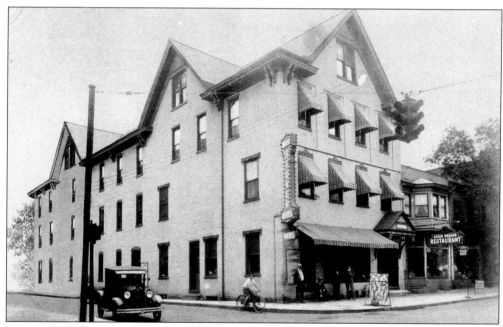

Muncy's Stover Hotel was operated by Maurice Stover and advertised rooms that were "Modern and Reasonable." It was considered among the best of the local hotels and was equipped throughout with Simmons all-steel furniture. The Green Dragon Restaurant was located next door.

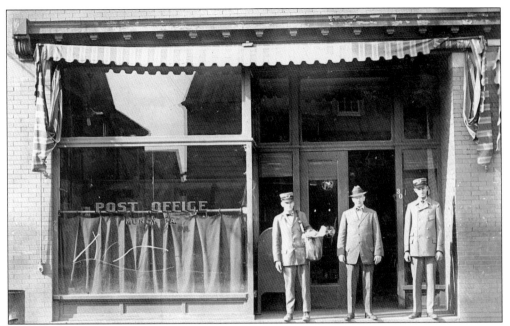

A post office was established at Muncy on April 1, 1800, and Henry Shoemaker was appointed postmaster. This photographic postcard is of the Muncy Post Office and its employees from around 1920. Pictured are, from left to right, Lester Sedam, Bill Gowers, and Brady Snyder. The post office was located on the corner of Plum Alley and Main Street.

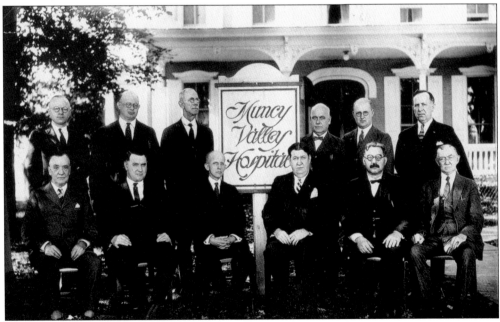

Physicians and founders of the Muncy Valley Hospital were, from left to right, (first row) C. E. Albright, W. E. Turner, T. K. Wood, F. Gordner, G. Alvin Poust, and Charles D. Vorhees; (second row) H. F. Baker, H. K. Davis, W. L. King, Daniel D. Kiess, Irvin T. Gilmore, and D. M. Nipple.

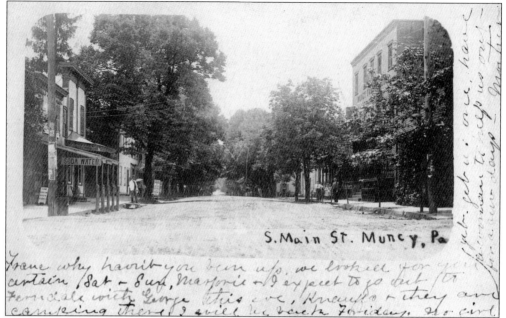

This postcard of South Main Street was sent on August 8, 1906, to Francis M. Everett Jr. of Montgomery. It reads, "Franc, why haven't you been up. We looked you certain Sat & Sun. Marjorie and I expect to go out to Ferndale with George this even. Knauffo & they are camping there. I will be back Friday. No find job. Get one. have allowance to help us out for a few days. Martin."

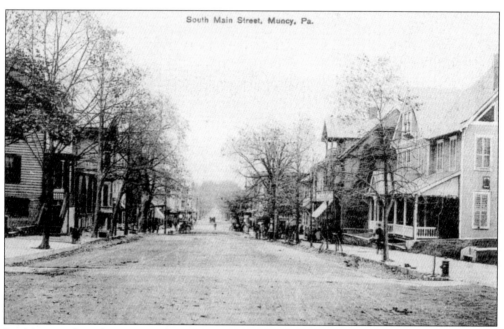

South Main Street, Muncy, Pa.

Looking north at the corner of Main and Water Streets, this photographic postcard was made around 1900. The Noble and Petrikin dry goods store is on the corner. Next to it is the original location of the Muncy Banking Company, a piano and organ store, the H. S. Maurer Meat Market, then the Crawford House, which also housed a millinery store.

66

This property at 100–102 South Main Street, on the southwest corner of Main and High Streets, formerly was known as the Eagle Hotel. One of the oldest commercial buildings in town, it may date to the early 1800s.

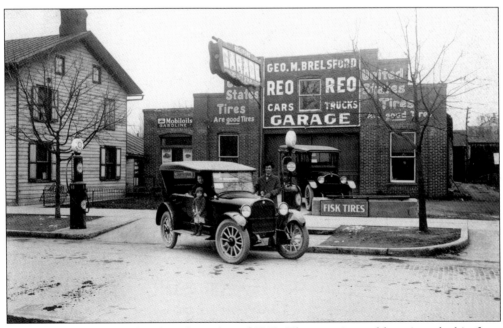

The Reo Car was introduced in the spring of 1922. The one pictured here is parked in front of George M. Brelsford's Garage in Muncy. It was manufactured by Ransom Eli Olds, who, in 1897, founded the Olds Motor Works and later invented the Curved Dash Oldsmobile, the first mass-produced automobile. He severed his ties with Olds, and in 1904, he incorporated the Reo Motor Car Company.

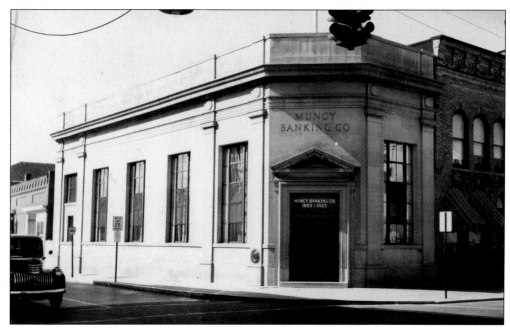

The Muncy Banking Company was opened on November 1, 1893, by Muncy businessmen, under the leadership of Lewis S. Smith, a successful store owner. Smith's son, L. Clyde Smith, became president in 1914, operating it until his death in 1938. This building, located on the corner of Main and Water Streets, opened on May 29, 1926.

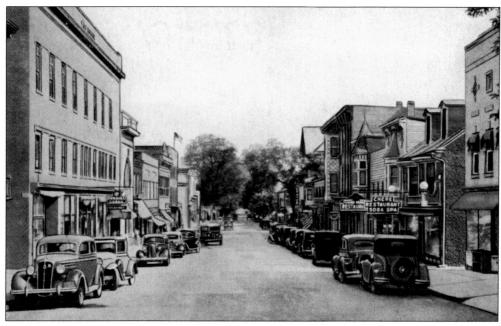

This postcard sketch is of South Main Street around 1925. At right is the Golden Dragon Restaurant, and farther down the same block is the Stover Hotel.

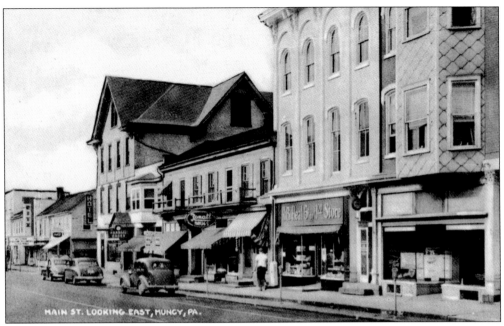

Looking east along Main Street, this postcard features H. B. Heal's department store on the right. Past it is the Ritz Theatre, which opened on January 23, 1923. In 1934, the Ritz Theatre was sold to Dorothy and Harold Larned, who operated it until 1967.

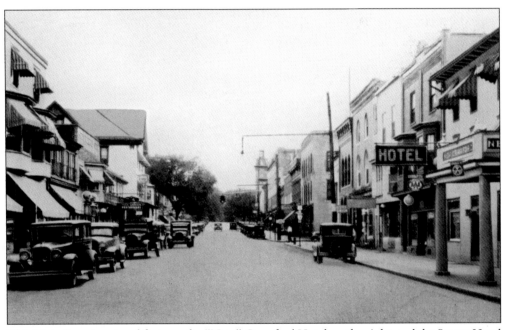

This Main Street postcard features the "New" Crawford Hotel on the right, and the Stover Hotel on the left. In the distance is the dominant facade of Penn Hall, now known as the Margaret Waldron Building.

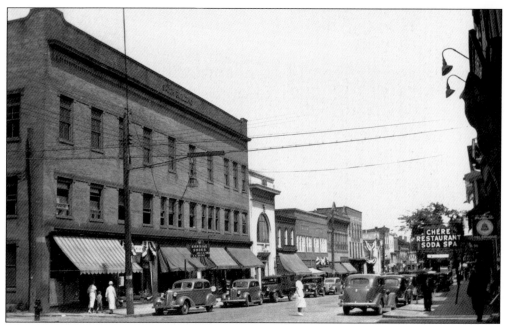

The Smith Building, at 22–30 South Main Street in Muncy, was built by James Wagner for the prosperous and prominent Smith family. This photograph shows Main Street around 1935.

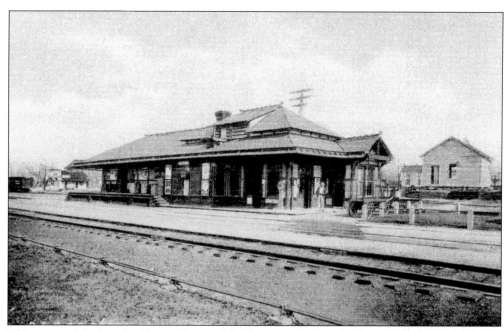

This postcard depicts the Muncy depot of the Reading Railroad. Along with the West Branch Canal, the Reading Railroad station helped Muncy expand to its zenith during the latter half of the 19th century.

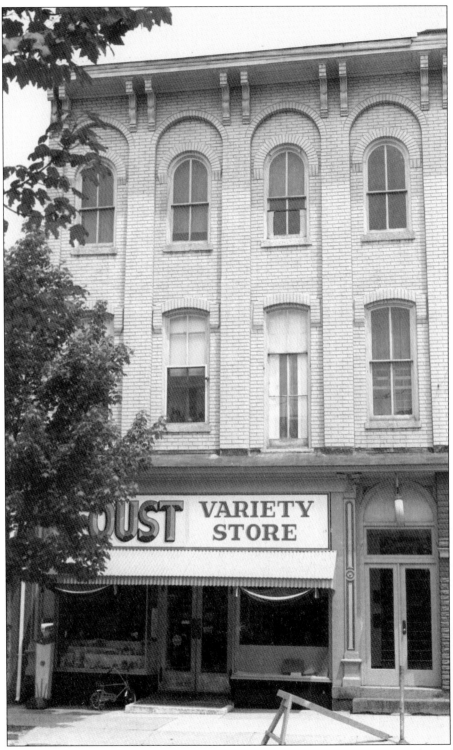

Once known as the bustling mercantile Tallman and McCarty's, Foust Variety Store later occupied this storefront on South Main Street.

The Painter brothers and their sons were active in Muncy as newspaper publishers and druggists. Pictured from left to right at the corner of Main and High Streets are George Painter's house and the Painter Drug Store flanking L. C. Koons Plumbing storefront.

The 100 block of South Main Street was the home of the *Muncy Luminary*, at right. The *Muncy Luminary* was the successor of the *Muncy Telegraph*. It was founded on April 10, 1841, by W. P. L. and G. L. I. Painter.

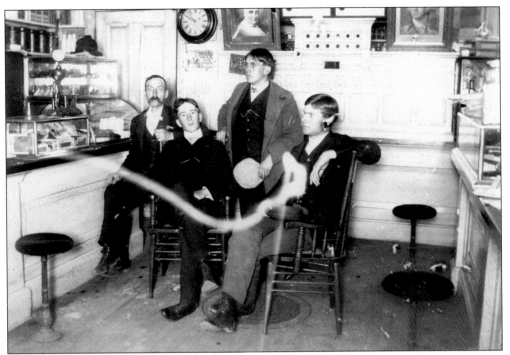

Posing inside of Painter's Drug Store are, from left to right, Albra Painter, an unidentified customer, Harry Painter, and another unidentified customer.

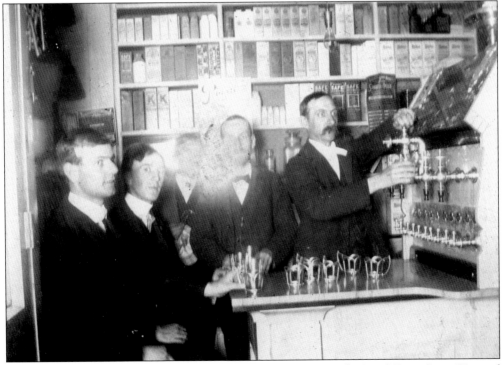

Albra Painter, far right, mixes a fountain soda behind the counter of Painter's Drug Store. Pictured from left to right, two unidentified customers pose with Harry and Thomas Painter.

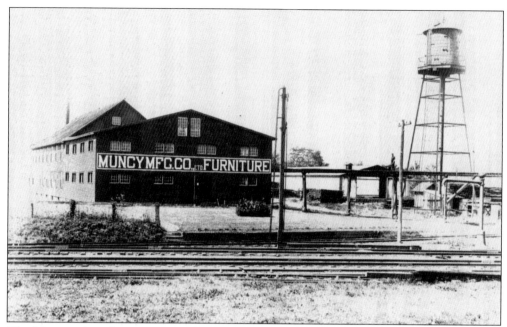

The Muncy Manufacturing Company produced furniture. The company was organized in 1887, and its officers were George H. Rogers, president; A. B. Worthington, superintendent and treasurer; and W. F. Brittain, secretary and bookkeeper. Located between the railroad and canal, the company shipped hardwood chamber suites, sideboards, and a line of common beds.

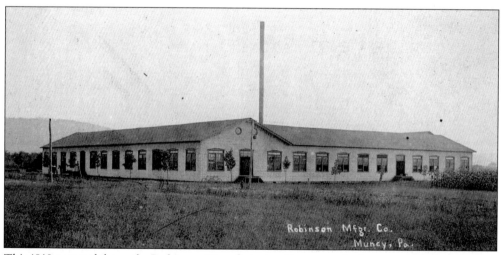

This 1910 postcard shows the Robinson Manufacturing Company. An important Muncy industry, Robinson employed about 200 people engaged in the manufacture of milling machinery.

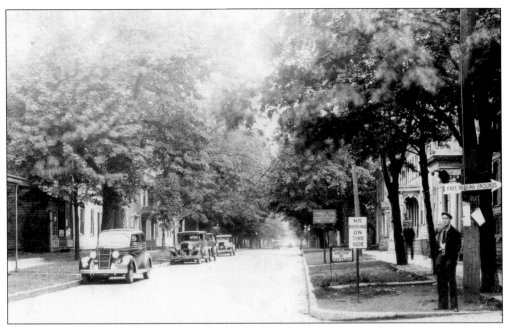

Frey Travelers Rest apartments and garage and W. S. Weaver, justice of the peace, were located at the corner of Main and High Streets, looking south.

Formerly used for the Trumbower Factory, Muncy Traction Engine Company, Murray Ice Plant, and assorted other things, this building sits along Glade Run, the west side of East Water Street.

The Hoffman Seed and Grain Company had several storage facilities for collecting and processing seed corn that was shipped all over the northeast. In the foreground, at the corner of Plum and McCarty Alleys, is the gas company's building.

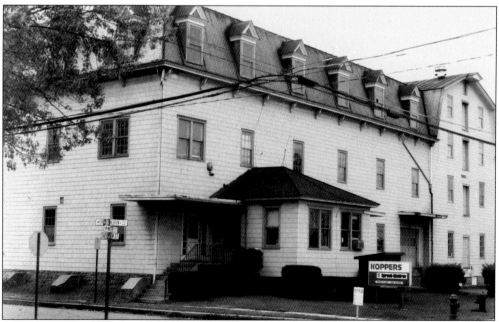

This facility at the corner of Sherman and Water Streets was built by Anson P. Taylor and Theodore B. Eaker and then sold to Charles E. Vermilya, who managed the City Flouring Mill until 1957. It became the experimental laboratory of the Sprout Waldron complex.

The former silk mill on Carpenter Street had a succession of owners such as the Pants Factory. The Maxwell Silk Company operated it from 1927 to 1941 when it closed.

Keystone Filler Manufacturing Plant has been in existence, in one form or the other, since 1877. They made paints to coat blackboards, and ready-mix paints in several colors.

Charles Waldron, a former president of Sprout Waldron, poses for a company portrait. Started by L. B. Sprout, the company first manufactured haying tools. The factory relocated to Muncy to have access to the Reading Railroad extension and the West Branch Canal.

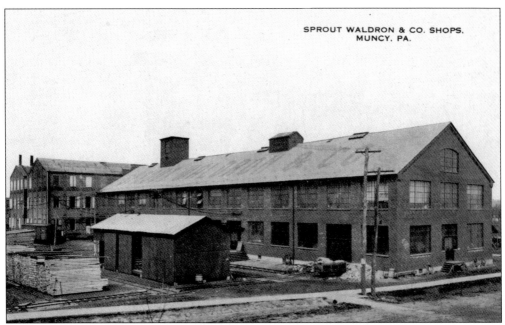

This postcard of Sprout Waldron Manufacturing Company was mailed to W. F. York of Manlius, Illinois, on September 18, 1918. It reads, "Dear Will: We are uptown taking in the sight. We walked up from Uncle Charlies. I went down to Uncle Will Ruperts and got your letter. I was glad to hear from you. We are going to start home in a few days but don't know just when it will be. Well I must go they are waiting outside this post office. From your Dora."

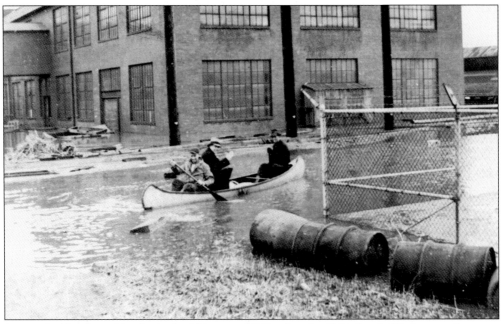

Sprout Waldron's parking lot looked like a pool following the 1936 flood. Workers used a canoe to check on the plant. The company also manufactured bolters, purifiers, French burr mills, hay elevators, forks, hooks, grapples, and pulleys.

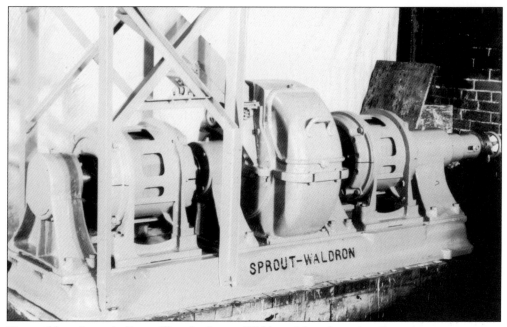

Pictured here is a grinding mill at the Sprout Waldron Manufacturing Company.

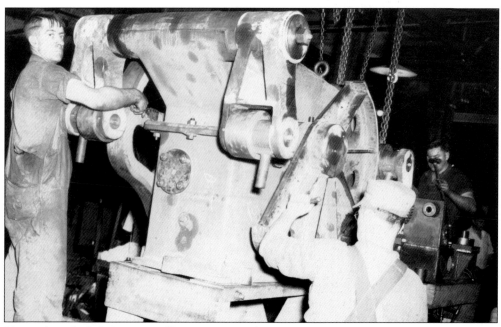

Pictured on the left, Norm Hoffman operates a hammer mill at Sprout Waldron's.

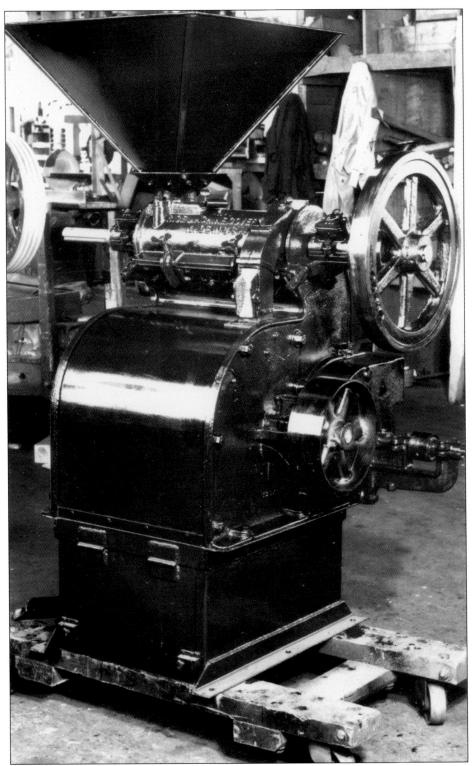

A hammer mill at Sprout Waldron's is pictured here.

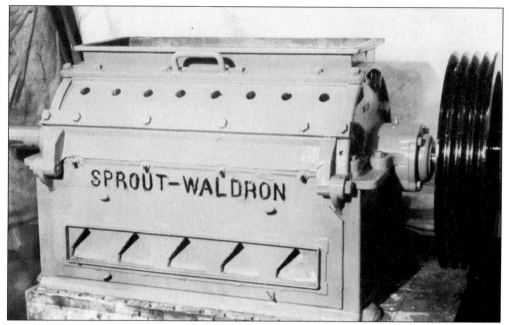

Here is another view of a hammer mill at the Sprout Waldron Manufacturing Company.

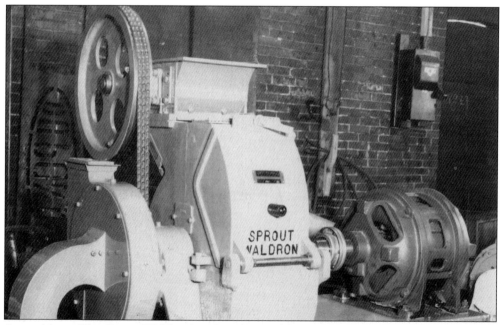

An attrition mill at Sprout Waldron's is the subject of this photograph.

A workman inspects the interior of a hammer mill at Sprout Waldron's.

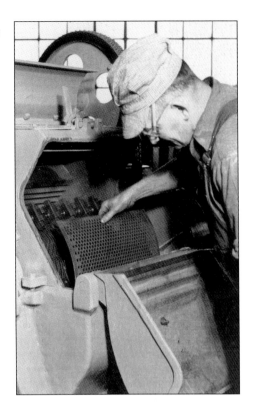

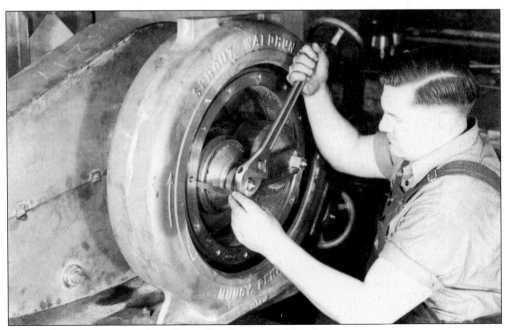

Don Artley services an early pellet mill at Sprout Waldron's.

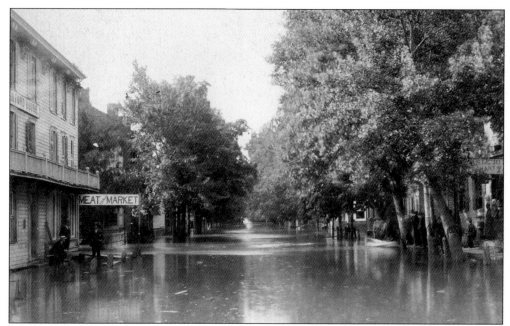

In this postcard, business is at a standstill in downtown Muncy following the flood of 1889. At left, water recedes to the top of the porch of the Crawford House and the H. S. Maurer Meat Market.

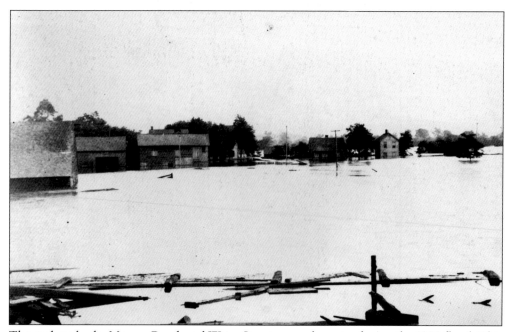

The coal yards, the Muncy Canal, and Water Street are underwater during the 1889 flood. This photograph was taken from the bank at Engine House.

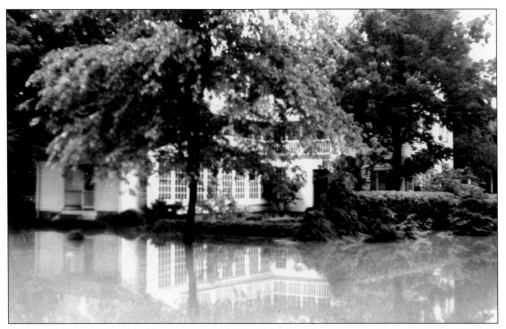

On March 17, 1936, a flood known as the St. Patrick's Day flood, swept down the West Branch. The first floor of the Clapp house was awash with about three feet of water. This photograph features the restored Clapp house, home of the Muncy Historical Society. The house has experienced dozens of floods, at least 10 where water reached the first floor. The 1972 flood caused by Hurricane Agnes was the worst, bringing at least five feet of water into the first floor.

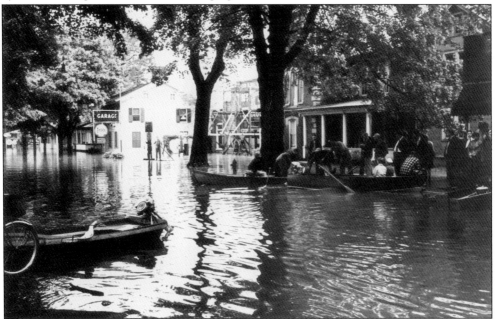

At the height of the 1936 flood, Brelsford Garage was underwater. According to *Gazette and Bulletin* news reports, the river rose at the rate of six inches per half hour and at 4:00 a.m. on March 18, the West Branch of the Susquehanna River had reached 32.4 feet, five feet above flood stage.

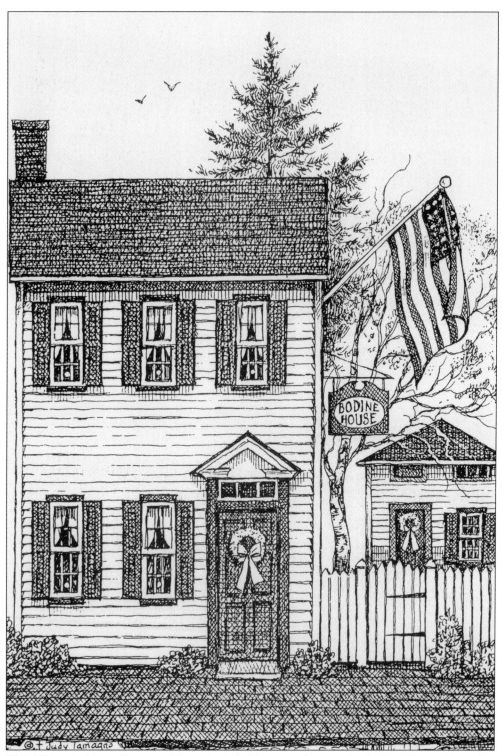

This "Historic Muncy" postcard by artist Judy Tamagno features the Bodine House, located at 307 South Main Street. The Bodine House is another of Muncy's early frame structures.

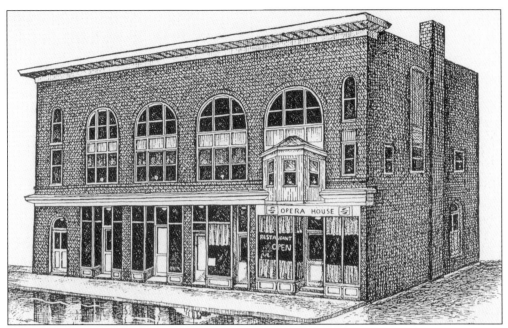

Another "Historic Muncy" postcard by artist Judy Tamagno, this features Mozley's Opera House, which was built in 1896 on East Water Street.

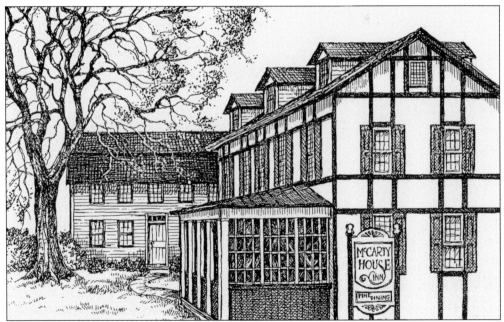

The McCarty House, located at 34 North Main Street, is the subject of this "Historic Muncy" postcard by artist Judy Tamagno. Brothers William and Benjamin McCarty are two of Muncy's founding fathers.

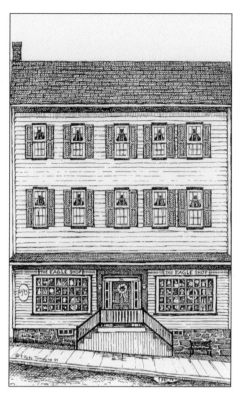

A "Historic Muncy" postcard by artist Judy Tamagno features the Banzhaf Bakery and confectionery storeroom, a three-story frame building at 36 South Main Street. W. H. Banzhaf established his bakery, one of the first in the county, in 1886 and then followed with a confectionery business in 1898. In 1919, he opened an ice-cream plant.

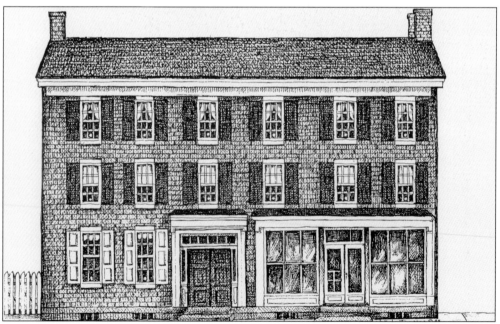

The Lloyd Titman House, built in 1856 at 300 South Main Street, is also featured on a "Historic Muncy" postcard by Judy Tamagno. Built by David Lloyd, the north side of the building was a storeroom, and the third floor was Muncy's first Masonic hall.

THE CITY FLOURING MILLS
EAKER & VERMILYA, Proprietors
High-Grade Monarch Gyrator Flour

MUNCY, PENNSYLVANIA
See Our Message on the Other Side

1910	OCTOBER					1910
SUN	MON	TUE	WED	THU	FRI	SAT
						1
2	3	4	5	6	7	8
9	10	11	12	13	14	15
16	17	18	19	20	21	22
23/30	24/31	25	26	27	28	29

Colorful postcards and calendars were advertising tools of local businessmen. Pictured here is Miss October of 1910. It was produced for the City Flouring Mills, makers of "High-Grade Monarch Gyrator Flour." The proprietors were Theodore B. Eaker and Charles E. Vermilya.

This postcard was "Compliments of Luby, Richardson and Co., Manufacturers of Fine Shoes, Albany, N.Y." It was an advertisement for G. Gowers and Son, who had "exclusive sale of these goods in Muncy."

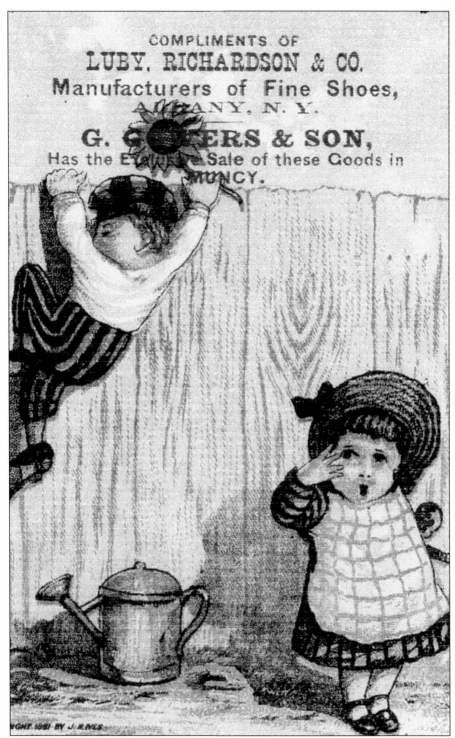

This is another postcard in the series designed by Luby, Richardson and Company, Manufacturers of Fine Shoes, of Albany, New York. It was an advertisement for G. Gowers and Son, who had "exclusive sale of these goods in Muncy."

This colorful postcard was sent to potential customers by W. H. Harman, Boots and Shoes of Muncy.

Pictured here is another example of the colorful postcards sent to potential customers by W. H. Harman, Boots and Shoes of Muncy.

This is another colorful postcard that was sent to potential customers by W. H. Harman, Boots and Shoes of Muncy.

Customers looked forward to receiving postcards such as this from W. H. Harman, Boots and Shoes of Muncy.

Here is another colorful postcard sent to potential customers by W. H. Harman, Boots and Shoes of Muncy.

This is another one of the colorful postcards that were sent by W. H. Harman, Boots and Shoes of Muncy to potential customers.

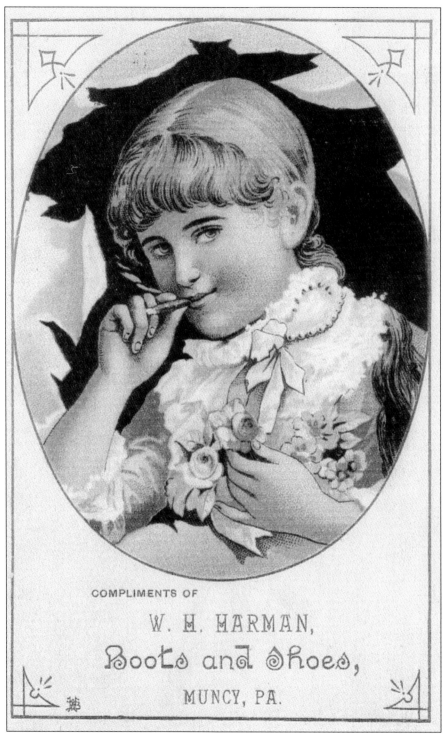

COMPLIMENTS OF

W. H. HARMAN,
Boots and Shoes,
MUNCY, PA.

This colorful postcard was sent to potential customers by W. H. Harman, Boots and Shoes of Muncy. Previously, the images have been of a domestic nature; however, this small girl is smoking a cigarette.

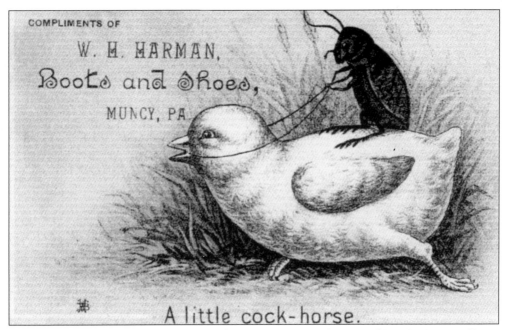

Another colorful postcard from a series, this was sent "Compliments of W. H. Harman, Boots and Shoes, Muncy, Pa. A Little Cock-horse."

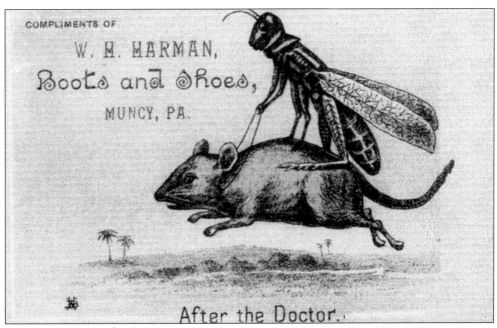

Another colorful postcard from a series, this was sent "Compliments of W. H. Harman, Boots and Shoes, Muncy, Pa. After the Doctor."

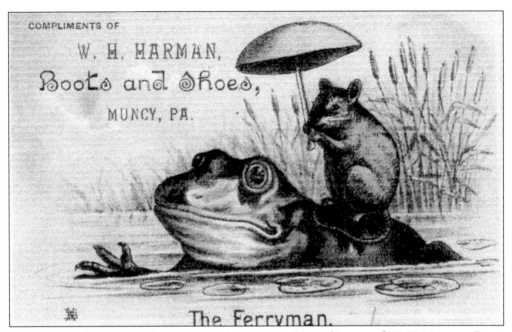

Another colorful postcard from a series, this was sent "Compliments of W. H. Harman, Boots and Shoes, Muncy, Pa. The Ferryman."

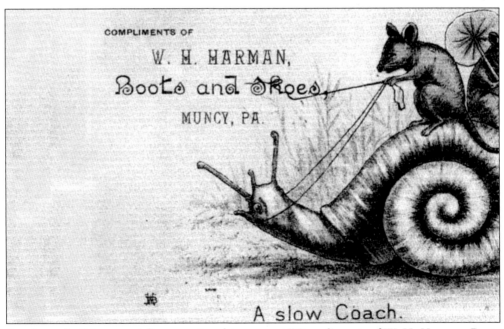

Another colorful postcard from a series, this was sent "Compliments of W. H. Harman, Boots and Shoes, Muncy, Pa. A Slow Coach."

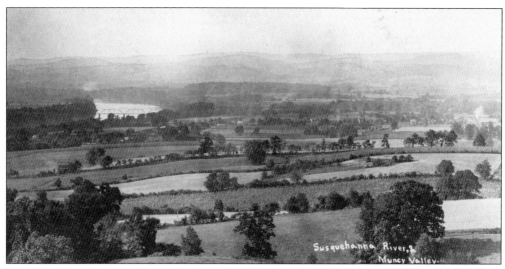

The West Branch of the Susquehanna River, looking down into Muncy Valley, makes for a scenic postcard.

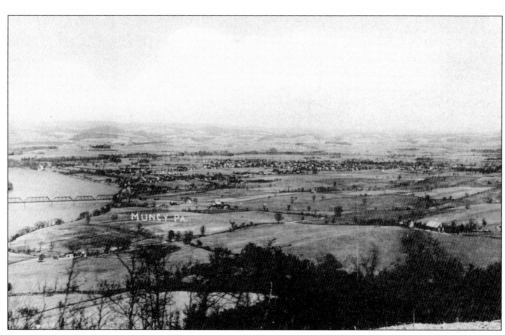

Here is a view of farmland to the south of Muncy, showing the Reading Railroad Bridge in 1910.

Four

THE RIVER

The Susquehanna River, stretching approximately 410 miles from New York to Maryland, is the longest river on the East Coast. Its North Branch, which begins at Otsego Lake in Cooperstown, New York, often is regarded as an extension of the main branch. Its primary tributary, the West Branch, rises in western Pennsylvania and joins the North Branch near Sunbury. The river drains into in the Chesapeake Bay.

The ancient river is possibly the oldest major system in the world, far older than the mountains through which it flows. Geologists believe that the mighty Susquehanna River cut through the mountains even as they were forming nearly 300 million years ago. If so, the river predates the Atlantic Ocean.

Time, however, has reduced the river to a shallow waterway. Early settlers lamented that the Susquehanna River was "a mile wide, a foot deep."

The West Branch of the Susquehanna River, when navigable, afforded an economical and ready means of transporting articles downriver, but to push a large boat or even a canoe against the rapid current, or over the shoals and rifts, was a formidable undertaking. For this reason, canals were built throughout Pennsylvania during the early 19th century, dug by men whose tools were picks, shovels, and wheelbarrows. Canals measured 28 feet wide on the bottom, 40 feet wide at the top, and 8 to 10 feet deep.

The West Branch Canal was constructed between 1828 and 1834, formally opening on July 4, 1834. At this time, the canal only reached the mouth of Loyalsock Creek. The first packet boat to navigate the West Branch Canal was the *James Madison*.

In 1847, the enterprising citizens of Muncy financed the Muncy Canal Company. The crosscut canal ran nearly a mile from the Port Penn section of the West Branch Canal into downtown Muncy, ending at the Woolen Mills Factory. L. B. Sprout relocated his business to Muncy, where it became successful because of its proximity to the canal.

This aerial view, taken around 1925, is the westerly side of Muncy Township and includes Muncy Farms, built by Samuel Wallis in the late 1760s.

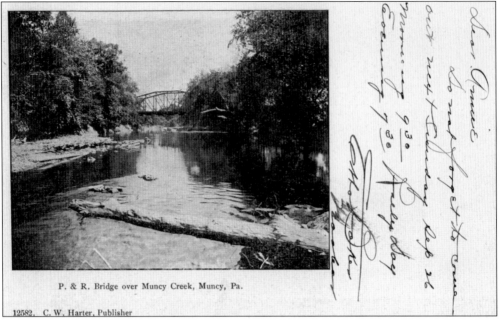

P. & R. Bridge over Muncy Creek, Muncy, Pa.

12582. C. W. Harter, Publisher

This postcard is of the Reading Railroad Bridge over Muncy Creek. Postmarked September 24, 4:00 p.m., it is addressed to Annie Narber of Muncy. It reads, "Dear Annie, Do not forget to come out next Sunday Sep 26 morning 9:30, Ella Baker Narber."

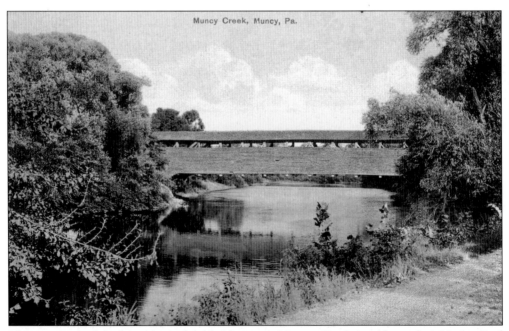

Muncy Creek, Muncy, Pa.

This postcard of the historic covered bridge over Muncy Creek is addressed to Master Paul Laurenson of Hughesville. It reads, "Hello Paul, how are you and the teacher getting along? Has she whipped you yet? See you soon, from Theodore."

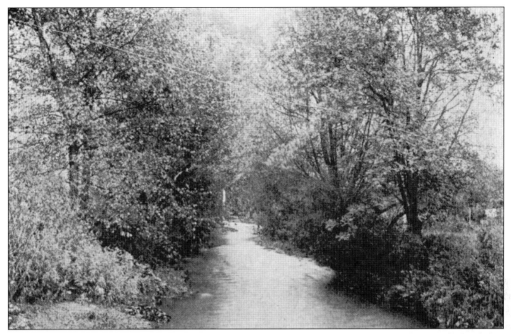

This postcard is of Glade Run, a creek in Muncy Creek Township. Capt. John Brady built his stockade house, known at the time as Fort Brady, near here.

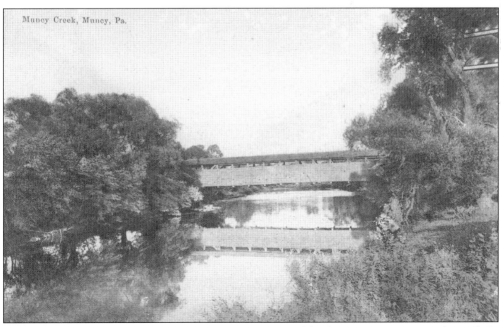

Muncy Creek, Muncy, Pa.

Here is a different postcard view of the historic covered bridge over Muncy Creek. Built in 1888, the Burr truss design is an 85-foot, single-span structure.

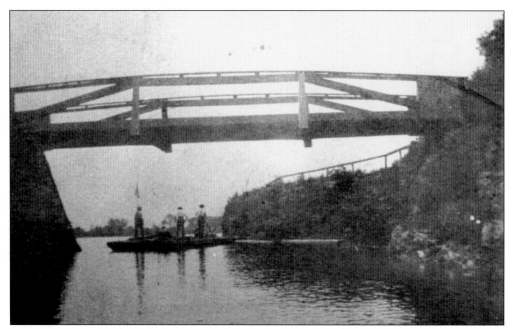

This 1895 photograph is of a bridge across the West Branch Canal at the Muncy Dam.

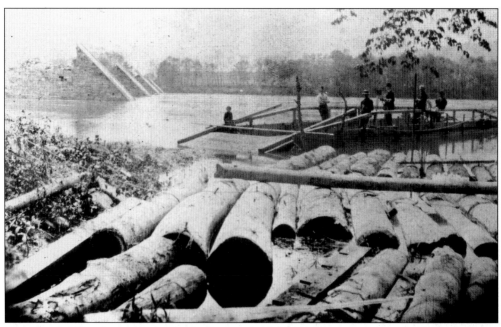

The four bridge abutments in the background of this 19th-century photograph are all that remain of the Muncy Bridge following a flood. The bridge was destroyed twice—once in 1865 and again in 1889. At right is the Muncy ferry with passengers aboard. A sawmill near the site accounts for the logs floating in the foreground. The ferry continued to operate until a new bridge was erected.

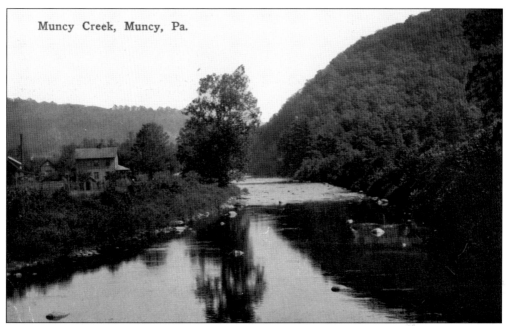

Muncy Creek, Muncy, Pa.

In October 1915, Mildred Kurtz was in the Williamsport hospital under the care of "Dr. North." This card to her reads, "Dear Mildred, I have been very anxious about you but now I hear nothing but encouragement and look forward for a short time when you will be home again and no doubt you will be much better than you was before you took sick. From your Uncle, A. B. Stolz."

Photographed at Gudykunst Hill during the 1889 flood, this north Muncy view shows entire farms underwater.

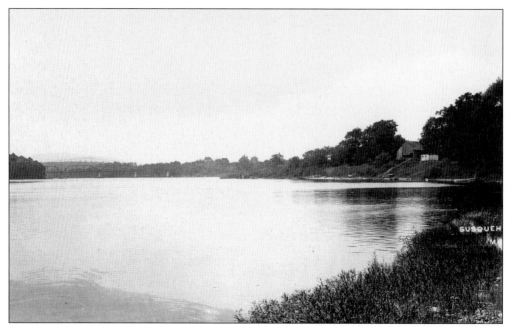

The lumber sawmill of Egli can be seen at right in this 1910 view of the West Branch of the Susquehanna River. Logs were kept in a small boom in the river and dragged up the slide leading into the mill. The log slide up to the mill can be seen at the far right.

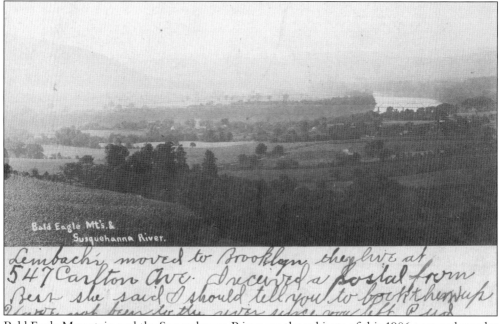

Bald Eagle Mountain and the Susquehanna River are the subjects of this 1906 postcard sent by H. H. Walton of 149 Pierpont Street in Brooklyn, New York. It reads, "Limbach's moved to Brooklyn they live at 547 Carlton Ave. I received a postal from Bess she said I should tell you to look though I have not been to the river since you left."

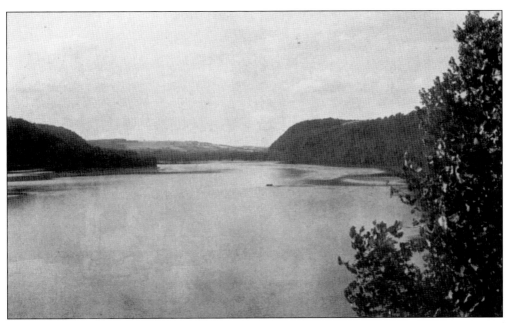

In the 1920s and 1930s, postcards often were printed with white borders. This card's view of the West Branch of the Susquehanna River was photographed from Muncy.

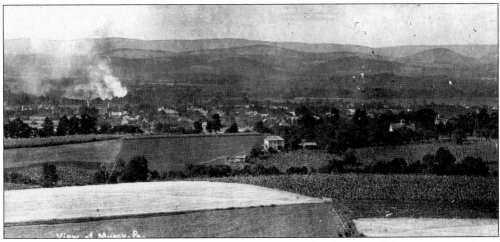

A fire rages in the background of this view of Muncy. In the foreground is a prosperous farm, with cornfields to the right and hay to the left.

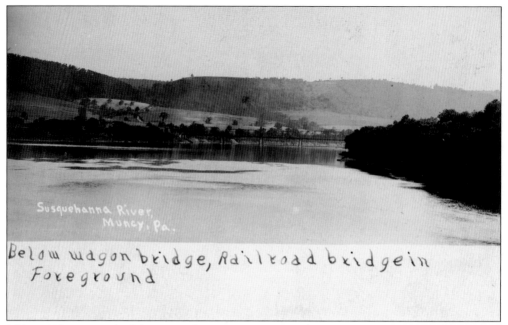

Susquehanna River,
Muncy, Pa.

Below wagon bridge, Railroad bridge in
Foreground

This *c.* 1885 postcard of the Susquehanna River reads, "Below wagon bridge, railroad bridge in foreground."

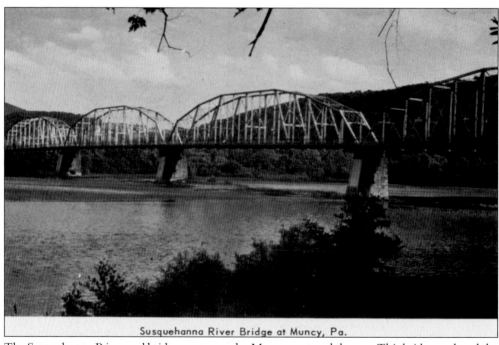

Susquehanna River Bridge at Muncy, Pa.

The Susquehanna River and bridge were popular Muncy postcard themes. This bridge replaced the covered bridge that went out in the flood of 1889, which was known as the "wagon bridge."

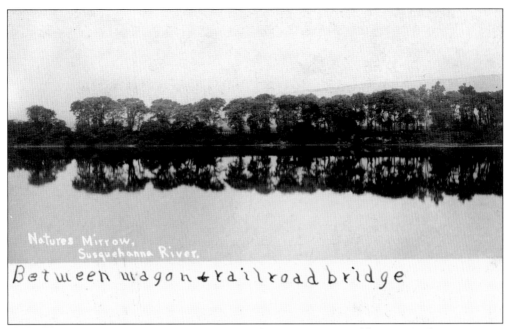

Titled "Natures Mirror, Susquehanna River," this *c.* 1885 postcard bears a similar message to the one before. It reads, "Between wagon and railroad bridge."

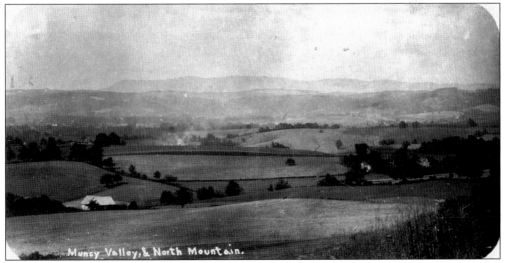

A pastoral scene, this postcard is of the Muncy valley and North Mountain.

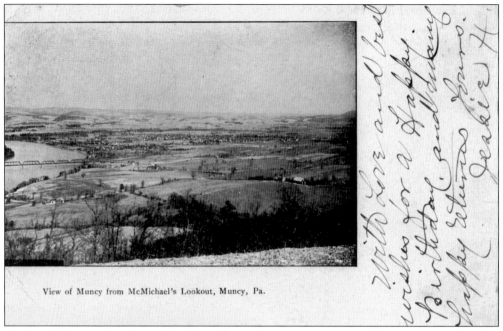

View of Muncy from McMichael's Lookout, Muncy, Pa.

A view of Muncy from McMichael's Look Out was sent via postcard from "Jessie H." to her friend "John" in Williamsport. It reads, "With love and best wishes for a happy birthday and many happy returns."

A postcard of Wolf Run in Muncy was sent to Mrs. W. L. Albright of Germantown, Pennsylvania. It reads, "Arrived all safe and sound but lost Ada at Tamaqua and her mother was cross cause she did not come on through. A crowd of us are going up to heights and lake on Sunday. I hope you get off all B. K. and S. sent you the mileage last night. M. C. A."

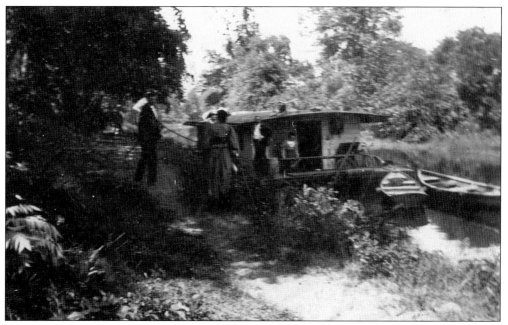

Here is one of Dr. Elmer S. Hull's houseboats that floated on the West Branch of the Susquehanna River from Hull's Landing.

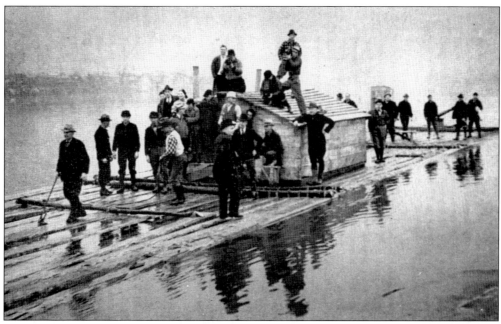

The most shocking news event in Lycoming County during 1938 was the tragedy of Pennsylvania's "Last Raft." Seven men died when the log craft crashed against the piers of the railroad bridge at Muncy on March 20, 1938, while on its historic trip down the West Branch of the Susquehanna River. Without warning, a carefree journey turned to tragedy before the horrified eyes of thousands of onlookers.

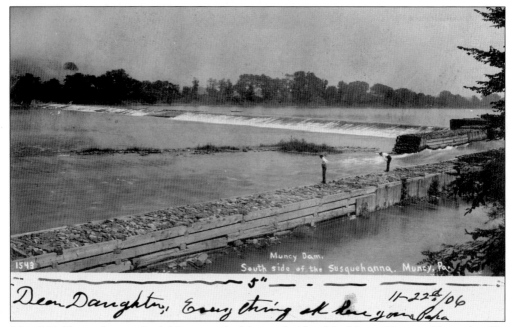

Muncy Dam,
South side of the Susquehanna, Muncy, Pa.

1543

Dear Daughter, Everything ok here your Papa 11-22ᵈ/06

Mrs. P. E. Shoemaker received this postcard of the south side of the Muncy Dam on November 22, 1906. It reads, "Dear Daughter, Everything okay here. Your Papa."

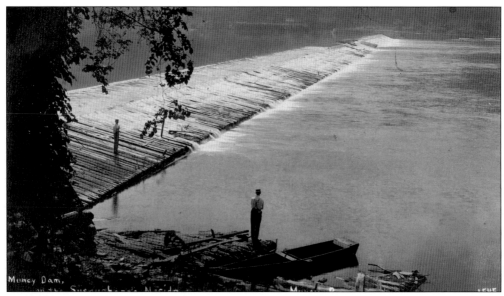

Muncy Dam,

Seen from the north side of the West Branch of the Susquehanna River, this view shows the Muncy Dam.

112

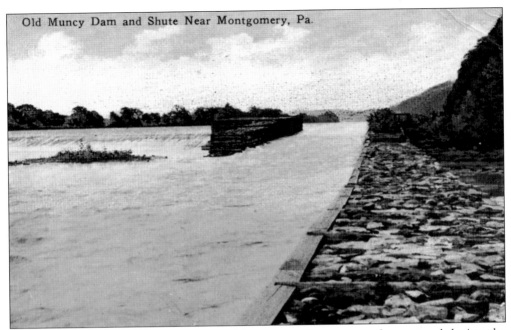

Old Muncy Dam and Shute Near Montgomery, Pa.

The "Old Muncy Dam and Chute near Montgomery" was a popular postcard during the canal era.

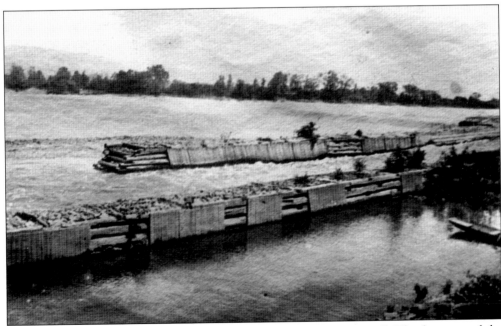

This pre-1910 postcard shows the Muncy Dam and Chute and wing wall. The dam created the Muncy Pool, an area of calm water where canal boats waited to enter Lock No. 20.

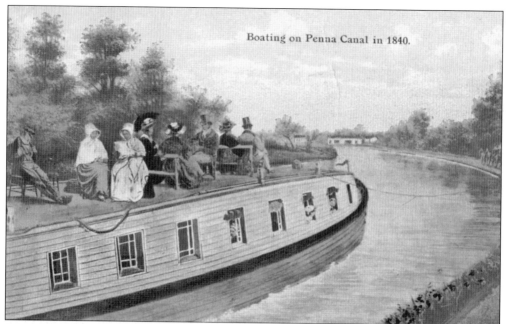

Boating on Penna Canal in 1840.

A popular postcard of the 19th century, this colorized sketch of a Pennsylvania Canal was circulated at every town along the West Branch Canal. It shows a packet boat transporting passengers on its roof. Boats were towed by mules walking the towpath. A speed limit of four miles per hour was imposed to preserve the canal's embankments.

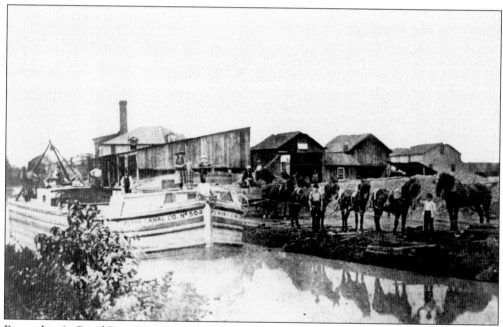

Pennsylvania Canal Boat No. 502 unloads coal at the Sprout Waldron Manufacturing Company plant in 1891. Coal was lifted out of the boat in a barrel by block and tackle and dumped into wheelbarrows. At right, 12-year-old Charles Fortney leads his family's mules.

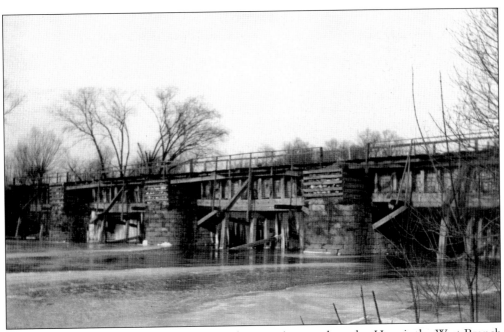

Aqueducts had to be built to carry the canal across rivers and creeks. Here is the West Branch Canal aqueduct that spanned Muncy Creek.

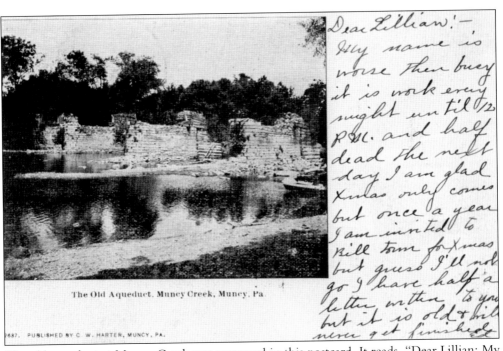

The Old Aqueduct, Muncy Creek, Muncy, Pa.

7687. PUBLISHED BY C. W. HARTER, MUNCY, PA.

The old aqueduct at Muncy Creek was preserved in this postcard. It reads, "Dear Lillian: My name is worse than busy, it is work every night until 12 p.m. and half dead the next day. I am glad Xmas only comes but once a year. I am invited to Billtown for Xmas, but guess I'll not go. I have half a letter written to you but it is old and will never get finished. Ed."

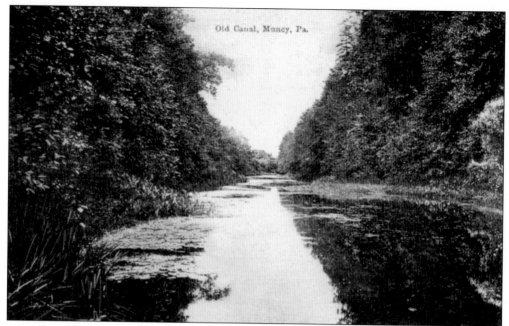

After floods in 1889, and again in 1894, the West Branch Canal was abandoned. Miles of the canal had been ruined, banks eroded, and locks smashed. Unused, the Muncy Canal soon became overgrown.

Throughout the nation, more that 4,000 miles of towpath canals were dug. In Pennsylvania, 1,356 miles of canals (more than in any other state) linked together its cities, villages, factories, mines, and farms.

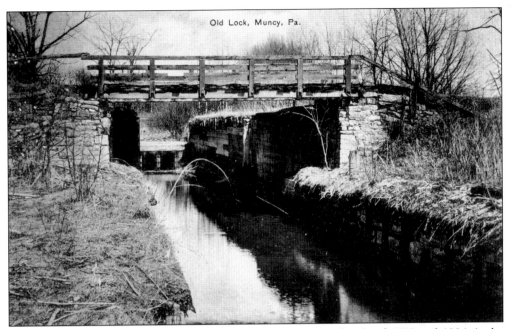

The Old Lock at Muncy, decrepit following the devastating floods of 1889 and 1894, is the subject of a postcard sent to Jessie Shoemaker. This lock is now part of the Muncy Historical Society's Heritage Park and Nature Trail.

The towpath of the West Branch Canal brought canal boats to the busy Port Penn section of Muncy.

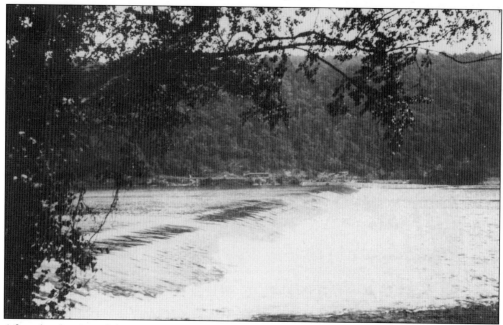

After the demise of the West Branch Canal, plans were made to dismantle the Muncy Dam and the chute.

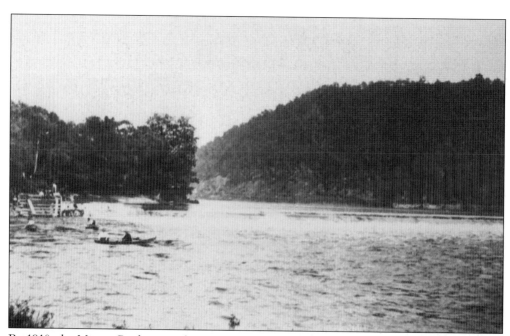

By 1910, the Muncy Pool was no longer needed. This postcard shows men in rowboats setting charges to prepare for the blasting of Muncy Dam.

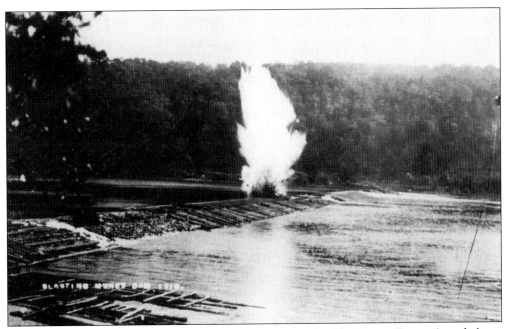

A plume of water and smoke is caught in this 1910 photograph of the Muncy Dam as it explodes.

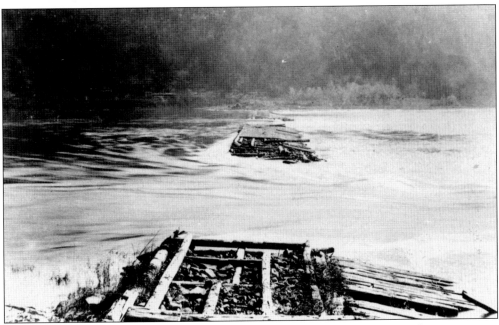

Muncy Dam is breached after blasting in 1910, and the river runs freely through it.

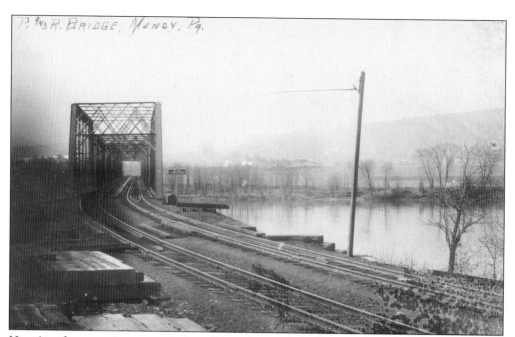

Here is a gloomy, winter perspective of the Reading Railroad Bridge at Muncy.

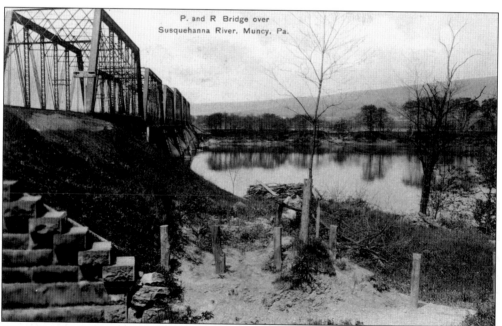

A Reading Railroad Bridge postcard sent to Alvin Suthiff of Central, Pennsylvania, reads, "Hello Alvin: I guess I ate about 'twelf' eggs more or less. My school leaves out on June 7th. I will then have three weeks vacation and then I expect to go to Ly. Co. Normal which is located here. I guess I will teach school next winter if nothing happens. Why don't you try teaching school? Think it would be a pretty good thing to start at. Milton."

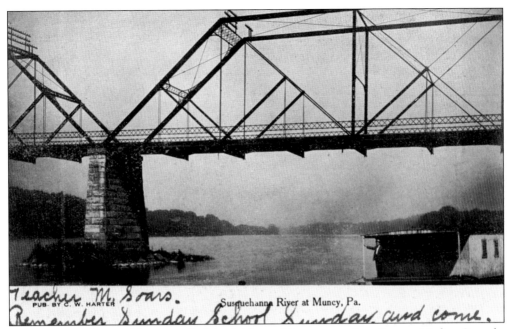

Teacher M. Soars sent this postcard of the bridge at Muncy to student George Narber. It reads, "Remember Sunday School Sunday and come."

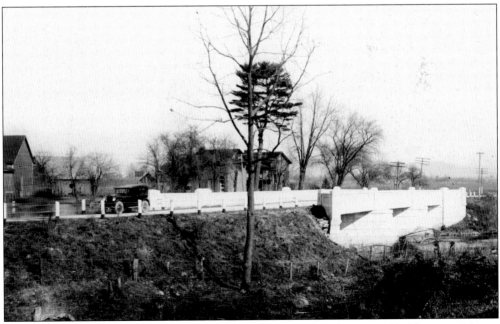

This photograph shows the new bridge, which replaced the historic covered bridge, over Muncy Creek at the wye.

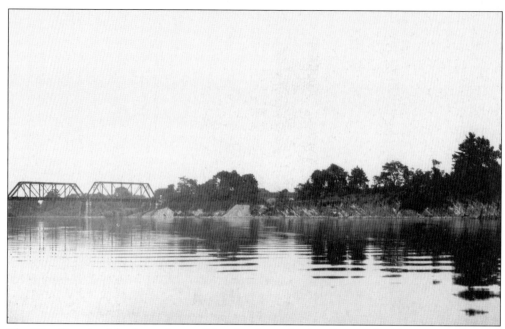

The West Branch of the Susquehanna River is calm at the Reading Railroad Bridge in Muncy.

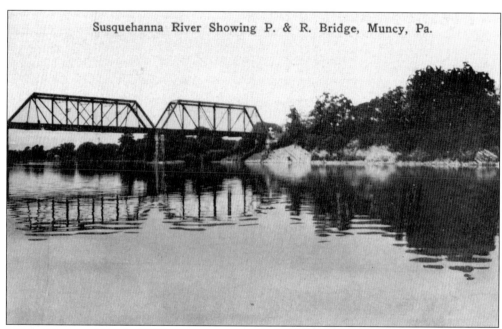

Susquehanna River Showing P. & R. Bridge, Muncy, Pa.

Mildred Kurtz, still in the Williamsport Hospital, received this postcard of the Reading Railroad Bridge. It reads, "Dear Cousin, I am so glad to hear that you are getting better. This is Saturday and I am raking leaves. And Sister is eating her breakfast. Grandma is getting better. Sit up a little yesterday. Yours, Ray Stolz."

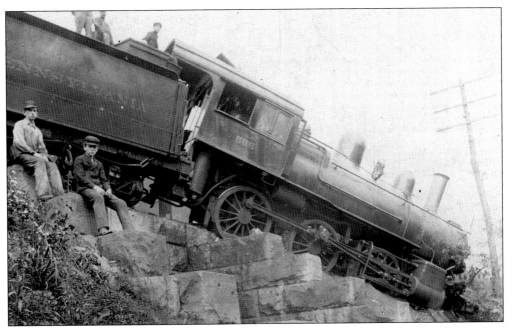

Shown on this postcard, dated September 12, 1903, is a train engine that wrecked at the Reading Railroad Bridge.

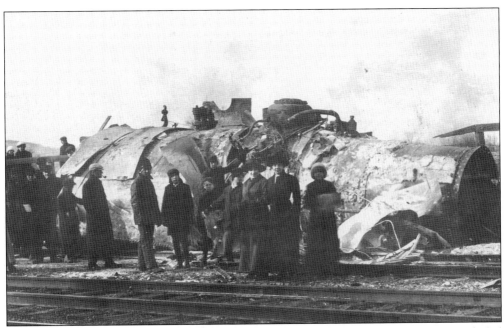

On March 1, 1912, at 7:41 p.m., a Philadelphia and Reading Railroad locomotive exploded in front of the Muncy Depot, killing four people and strewing wreckage 500 feet. Four of the six railroad employees on the train died. Killed were Bolton Whitenight, conductor; William Myers, fireman; Henry Robertson, brakeman; and William Fink, engineer.

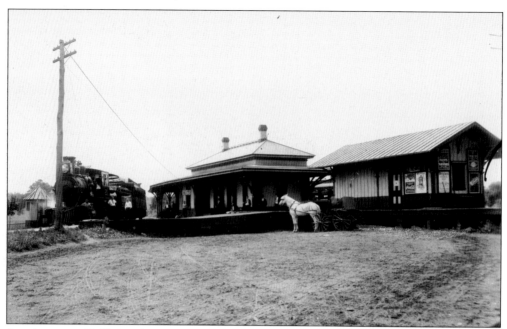

A train stops at Hall's Landing Depot, once located at the junction of Routes 220 and 147. Hall's once was the junction of the Reading and the Williamsport and North Branch Railroads.

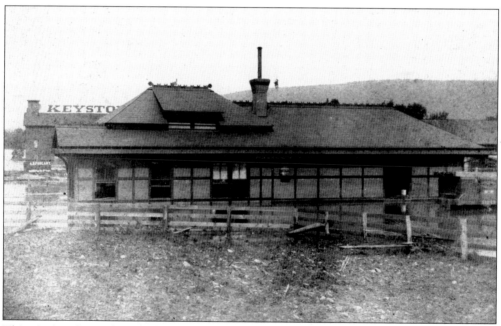

This picture shows the Reading Railroad Station (foreground) and the Keystone Company (background) on West Penn Street in Muncy during the 1889 flood. The depot is completely surrounded with water, although the ground in the immediate foreground is dry.

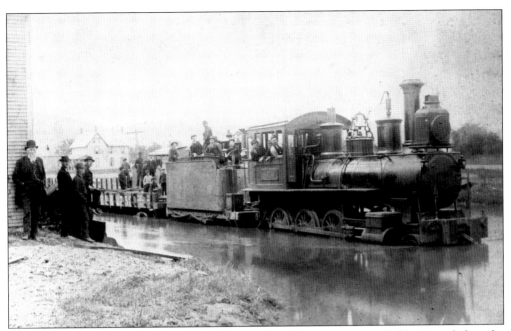

The engines and freight train on the Reading Railroad line are surrounded by water below the Muncy Depot following the 1889 flood.

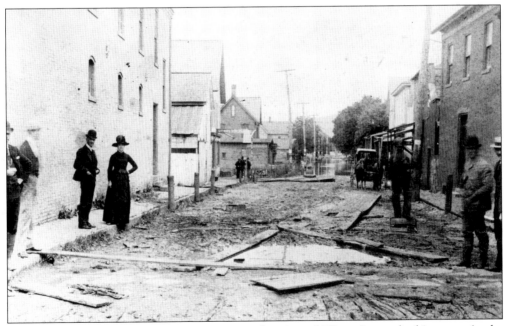

Townspeople view the damage at the corner of Main and Water Streets looking west in the aftermath of the 1889 flood.

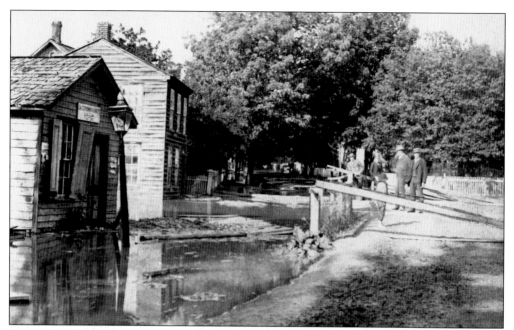

Shops along East Water Street including Traction Engine Works and Gardner Brother's Broom Making, as well as the Glade Run Bridge, are underwater following the 1889 flood.

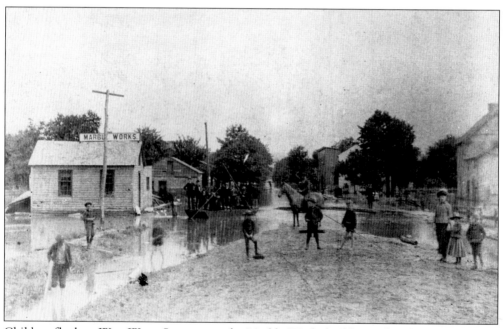

Children flock to West Water Street, near the Marble Works building, after the 1889 flood.

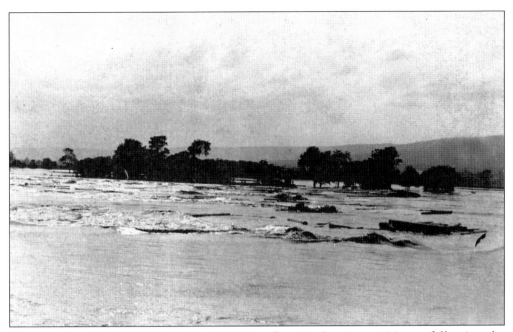

The remains of the Reading Railroad Bridge float in the river at Muncy following the 1889 flood.

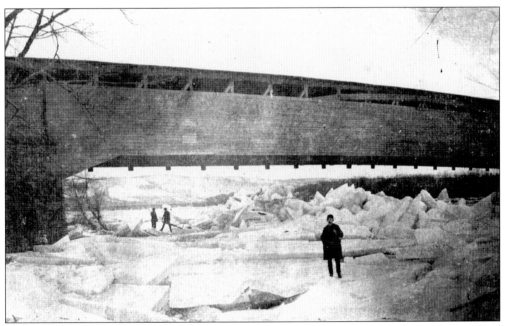

This bridge, one of the six sections of the covered bridge at Muncy over the West Branch of the Susquehanna, washed out in 1889. The second bridge was built in 1894 and remained in service until 1961.

ACROSS AMERICA, PEOPLE ARE DISCOVERING
SOMETHING WONDERFUL. *THEIR HERITAGE.*

Arcadia Publishing is the leading local history publisher in the United States. With more than 3,000 titles in print and hundreds of new titles released every year, Arcadia has extensive specialized experience chronicling the history of communities and celebrating America's hidden stories, bringing to life the people, places, and events from the past. To discover the history of other communities across the nation, please visit:

www.arcadiapublishing.com

Customized search tools allow you to find regional history books about the town where you grew up, the cities where your friends and family live, the town where your parents met, or even that retirement spot you've been dreaming about.